THE
SARAH
ANOINTING

MICHELLE McCLAIN-WALTERS

CHARISMA
HOUSE

International Version" are trademarks registered in the United States Patent and Trademark Office by Biblica, Inc.®

Scripture quotations marked NLT are from the Holy Bible, New Living Translation, copyright © 1996, 2004, 2007. Used by permission of Tyndale House Publishers, Inc., Wheaton, IL 60189. All rights reserved.

Visit the author's website at michellemcclainwalters.com, michellemcclainbooks.com.

Cataloging-in-Publication Data is on file with the Library of Congress.
International Standard Book Number: 978-1-62999-675-2
E-book ISBN: 978-1-62999-676-9

22 23 24 25 26 — 9 8 7 6 5 4 3 2
Printed in the United States of America

CONTENTS

MOTHER OF NATIONS

I will bless [Sarah], and she shall be a mother of nations; kings of peoples shall be from her.

—GENESIS 17:16

WE ARE LIVING in one of the most tumultuous times I've ever experienced. Sickness, death, change, men's hearts failing because of fear, doubt, unbelief, instability, and shakings are all around us. Generations are warring with other generations. This cultural change has brought devastation to families, cities, and nations. I hear the Lord saying, "Fear not!" His promises are true, and He does not change. He hasn't changed His mind about you and your destiny. He is still going to bless you and make you a blessing to your generation.

There is a plot of the enemy to seduce this generation of believers from the foundation of faith in the promises of God. We must return to the ancient paths. Psalm 11:3 asks, "If the foundations [of a godly society] are destroyed, what can the righteous do?" (AMP). We cannot allow doubt and unbelief to rule in our hearts. We must fight for the truth of the Word. We must fight to see truth and righteousness prevail in the earth.

There is a fresh impartation of faith in the true and living God being released in the earth. Just as Sarah, the mother of nations, did, we must look within ourselves and judge God as faithful! The focus of faith is knowing in whom we believe. Faith is more than understanding a particular promise. Sarah's journey teaches us that we must focus on the One behind the promise rather than the promise itself. God is raising up modern-day Sarahs who will be contenders for faith in the promise giver.

> I found it necessary to write to you exhorting you to contend earnestly for the faith which was once for all delivered to the saints.
>
> —JUDE 3

Contend means to fight for something while striving against the difficulties that hinder its release. Modern-day Sarahs will have a vision to contend for everything that God will give the human spirit in this generation.

God is releasing an army of women who will be a stabilizing force in these troubled times. Stability means you are secure in your position, not likely to fail or fall; you are steady, constant, and firm. Isaiah 33:6 says, "Wisdom and knowledge will be the stability of your times." There is a company of women who will be anointed with supernatural wisdom and knowledge that equip a generation to contend for the promise given to them. Woman of God, there is a clarion call going out in the earth for modern-day Sarahs to arise.

The company of women with the Sarah anointing will war according to the prophecies that are delivered to them

until they receive the promise. God is anointing you with the power to unlock all the promises and destinies that He ordained from the beginning of time for you and your family. He is releasing courage and mandating you to secure your inheritance and pass the legacy of faith in God to your children and your children's children.

Women are arising with legendary faith to believe God for the impossible. God will anoint these women with the Holy Ghost and power to demonstrate miracles and the mercy of God on a massive scale. Many women are being mantled with the spirit of might to accomplish some assignment for Jesus that will be nothing short of legendary.

God is awakening an army of women who will become mothers of the nations. They will break through natural and spiritual barrenness to conceive and bring forth His plans and purposes, just as Sarah did. This generation needs spiritual mothers. If we are to see the order of God established in the earth, it's going to take apostolic mothering grace as well as apostolic fathering grace.

Sarah had unshakable faith in an unshakable God. Modern-day Sarahs will believe God for the restoration of men and women as ones having dominion in the earth. These women will rule and reign in the earth alongside and in partnership with men. Gender wars are destructive. We will see faith, tenacity, and the love of God demolish the ancient war between men and women in the earth.

We are in a season when God is enlarging our capacity to receive our inheritance. God has a determined destination

for your life, and it's called the wealthy place, physically, emotionally, and spiritually.

God is empowering and equipping a company of modern-day Sarahs to step outside every box of insecurity, intimidation, and inferiority to make a global impact for His kingdom. These women will have vision to fight for the promises of God to be fulfilled in their lives as well as in the families of the earth. Jesus is redeeming lives from destruction. He is fulfilling promises and filling our mouths with laughter. He is redeeming time and restoring years lost. He is pouring out His mercy and lovingkindness upon His people. He is fulfilling dreams and giving many a second chance at life. Modern-day Sarahs, it is time to arise!

Becoming a Woman of Faith

Around four thousand years ago the Lord appeared to a man named Abram and made a covenant with him. The Lord told him:

> As for Me, behold, My covenant is with you, and you shall be a father of many nations. No longer shall your name be called Abram, but your name shall be Abraham; for I have made you a father of many nations. I will make you exceedingly fruitful; and I will make nations of you, and kings shall come from you. And I will establish My covenant between Me and you and your descendants after you in their generations, for an everlasting covenant, to be God to you and your descendants after you.
>
> —GENESIS 17:4–7

But the promises in God's covenant were not just about Abraham. Abraham's wife, called Sarai when God first appeared to him, also had a vital role:

> As for Sarai your wife, you shall not call her name Sarai, but Sarah shall be her name. And I will bless her and also give you a son by her; then I will bless her, and she shall be a mother of nations; kings of peoples shall be from her.
>
> GENESIS 17:15–16

At the time God spoke these words to Abraham, Sarah was not a mother at all, let alone a mother of nations. God was calling her according to her destiny. He was calling her future into her present.

God does the same thing with you. What has God said about you? By what name does He call you, invoking your promised future to intersect your present reality? It doesn't matter where you are now; God speaks to you from your future. God "calls those things which do not exist as though they did" (Rom. 4:17). Before Sarah became a mother, the Lord called her a mother of nations, even as He began to orchestrate the events that would create the spiritual environment necessary for her nature to be changed.

Sarah walked with her husband through a transformation. They became people of faith. If you recall, at the beginning of their story, in Genesis 12, Abraham and Sarah lied. When they went to Egypt, Abraham decided to say Sarah was his sister, and Sarah went along with it. Even though God had already promised Abraham, "I will make you a great nation;

I will bless you and make your name great; and you shall be a blessing. I will bless those who bless you, and I will curse him who curses you; and in you all the families of the earth shall be blessed" (Gen. 12:2–3). Abraham was afraid for his life. Neither his faith nor Sarah's was yet at the point where they truly trusted God to fulfill His promise.

Abraham and Sarah had taken their first step of faith when they obeyed God and left Abraham's father's house and their country, but their faith still had some growing to do. And God was taking them through the process of becoming the father and mother of faith.

God's plan was to make nations and kings from Abraham and Sarah's union. And the legacy of their union is one of faith. As a member of one of "the families of the earth" referenced in Genesis 12:3, you have inherited not only the promised blessing (which refers to Jesus) but also the legacy of faith. The calling of Abraham and Sarah was about family, about passing down the covenantal blessings of God from one generation to the next, about a heritage of faith and hope, about blessing all the nations of the earth through the faith of one couple.

In a time when more and more people are leaving the church and walking away from the faith, the Sarah anointing is critically important. It is time for women to rise up to infuse the next generation with hope so that faith may rise in their hearts again. The generations are crying out for the hope and faith that you have. It is a part of your spiritual legacy, and you need to pass it down to the generations coming after you, both natural and spiritual.

Sarah was a loyal wife who followed her husband when God spoke to him. Even when Abraham made mistakes, Sarah still called him lord. She was an active participant in the vision—maybe even too active. She ran ahead of God and tried to fulfill His covenant in her own timing and her own way. She also laughed at the possibility of a miracle. But ultimately, despite her mistakes, Sarah became a woman of faith, so much so that she is one of only two women mentioned by name in the Hall of Faith:

> By faith Sarah herself also received strength to conceive seed, and she bore a child when she was past the age, because she judged Him faithful who had promised. Therefore from one man, and him as good as dead, were born as many as the stars of the sky in multitude—innumerable as the sand which is by the seashore.
>
> —HEBREWS 11:11–12

God's covenant promise was fulfilled by Abraham and Sarah working together. His plan included both of them, so both Abraham's and Sarah's names were changed. And when God changed Sarah's name, He changed her nature. While Sarai and Sarah have similar meanings (Sarai means princess,[1] and Sarah means princess, noblewoman, or queen[2]), the name change signaled the new role God was calling Sarah to: mother of nations. The name change linked her to Abraham in co-rulership and included her in the covenant promise. God includes women in His covenantal purposes.

Sarah's life is a positive lesson in faith that breaks personal

limitations. When you are walking in faith, there is nothing that can keep you from pursuing your God-given vision. Sarah is also an example of a woman with a submitted spirit who responded biblically to her husband without losing her own identity. She was OK with who she was, and she was OK with not being perfect, knowing that even her mistakes were part of the learning and growing process as she was transformed from a barren woman to the fruitful mother of nations.

Sarah was also a watchman over and a contender for the promise—the plans and purposes of God. Even though she initially made a mistake in trying to bring about the promise outside of God's plan, that mistake was still an attempt to selflessly see God's plan through. She was committed to the purposes and plans of God, even if it meant sacrifice on her part.

What Is the Sarah Anointing?

The covenant of God passes down through families, both natural and spiritual. But the family has been under attack. God is looking for mothers and fathers who are visionaries, who will contend for the vision of expanding and growing the kingdom of God as they pour into the next generation and the nations. And God is including women in His purposes and plans for the next great awakening. As women, we cannot get away from our desire to birth things in whatever capacity, whether physical or otherwise. Our biological predisposition to give birth to natural children is not the only

way women initiate new life. We birth ideas, strategies, solutions, and entire movements. That's the way God made us. Woman of God, the Lord has given you the capacity to carry the promise. It's time to step up and become a woman of faith, a woman of vision, a woman of hope.

The Sarah anointing is about giving birth to the nations. While *nations* can refer to specific geographical areas, the word can also refer to other groups of people, both in the natural and the spiritual. While for some women the Sarah anointing is about physically giving birth to children, it is not limited to that. The Sarah anointing is also about giving birth to spiritual children. It is about going from barrenness to fruitfulness and the idea of multiplication. It is about receiving strength from the power of the Holy Ghost to break through the impossibilities and carry the promises of God. It is about extending the blessing of the Lord from generation to generation.

Sarah gave birth to one son, Isaac. But because of her one son, millions of people have been born, spreading out all over the earth. Sarah may have had a small beginning, but it resulted in a bigger, better, stronger, mega ending.

> Listen to me, all who hope for deliverance—all who seek the Lord! Consider the rock from which you were cut, the quarry from which you were mined. Yes, think about Abraham, your ancestor, and Sarah, who gave birth to your nation. Abraham was only one man when I called him. But when I blessed him, he became a great nation.
>
> —Isaiah 51:1–2, NLT

From one man and one woman came a great nation. You are only one woman, but God can cause the fruit you bear in your life to become a great nation. Whether it is your natural children or the spiritual children who are a result of your pouring into others, God will use your children to bless the nations and build His kingdom. They are children of promise.

Modern-day Sarahs are those who will take hold of the promises of God and be committed to seeing those promises fulfilled. They will "contend earnestly for the faith" (Jude 3). Women with the Sarah anointing have faith that breaks personal limitations and breaks barrenness, with fruitfulness the end result. They are willing to go through the process of transformation and growth that builds the capacity for miracles.

Keys to Activating the Sarah Anointing

> For in this manner, in former times, the holy women who trusted in God also adorned themselves, being submissive to their own husbands, as Sarah obeyed Abraham, calling him lord, whose daughters you are if you do good and are not afraid with any terror.
>
> —1 PETER 3:5–6

The Sarah anointing is for the daughters of Sarah, women who boldly pursue the purposes of God and walk in the good works that God prepared for us from the beginning. There are seven keys to activating the Sarah anointing.

1. Using wisdom in decision-making

Sarah was an excellent decision-maker. She may not have always made the right decision at first, but as her faith grew, so did her wisdom. The modern-day Sarah is not indecisive but instead possesses the wisdom to make godly decisions. Because of that wisdom, "the heart of her husband safely trusts her" (Prov. 31:11).

2. Being helpful

Sarah was her husband's helper, or helpmeet. The term is first used in the Bible in Genesis 2:18, when God said, "It is not good that man should be alone; I will make him a helper comparable to him." Sarah was a helper comparable to Abraham, and the help she provided was more than just handling household affairs. She was an integral part of the vision God had given them. Theirs was a covenantal family, and Sarah's role was vital in protecting that family and helping them move forward in fulfilling the plans and purposes of God.

Helper is one of the names of the Holy Spirit (John 14:26). And some of the characteristics of the Holy Spirit as our helper are also found in women. For example, the Holy Spirit is the spirit of wisdom, and that same spirit of wisdom is found in women with the Sarah anointing. Their God-given wisdom is a help to their husbands, their children (both natural and spiritual), and the others that they pour into.

And even if you are a single woman, you are still a helper. Isaiah 54:5 says, "For your Maker is your husband, the Lord of hosts is His name." While you may not have an earthly

husband at your side, you can still surround, protect, aid, and help the plans and purposes of the Lord.

3. Possessing internal and external beauty

The Bible says Sarah was "a woman of beautiful countenance" and "very beautiful" (Gen. 12:11, 14). But her external beauty was a reflection of her internal beauty. As a woman, you are "fearfully and wonderfully made" (Ps. 139:14), with external beauties unique to just you, but you need the internal beauties too. First Peter says, "Do not let your adornment be merely outward—arranging the hair, wearing gold, or putting on fine apparel—rather let it be the hidden person of the heart, with the incorruptible beauty of a gentle and quiet spirit, which is very precious in the sight of God." External beauty can fade, but when you are beautiful on the inside, it remains. The modern-day Sarah has inner beauty: kindness is on her tongue (Prov. 31:26); she does good (1 Pet. 3:6); she works hard (Prov. 31:13); she believes what God has told her (Luke 1:45); and she is full of the fruit of the Spirit (Gal. 5:22–23).

4. Walking in unity

Sarah shared an understanding with Abraham. They moved together in all the important areas of their lives. They were "like-minded, having the same love, being of one accord, of one mind" (Phil. 2:2), so they were able to walk in unity. And that unity was key to the vision God had given them.

Modern-day Sarahs cultivate that spirit of unity. They know women are like thermostats that can control the temperature or atmosphere of a home, and they want to

be women who create an atmosphere of cooperation that pulls out the best in other people. Women with the Sarah anointing see others from God's perspective, so they can see past the flaws and see greatness. They are agreeable, collaborative, and welcoming. They know that for two people to walk together, they have to be in agreement.

> Can two walk together, unless they are agreed?
> —Amos 3:3

5. Being fearless

Sarah was fearless. First Peter describes this quality as "not afraid with any terror" (3:6). The modern-day Sarah acts with courage and boldness because she knows the Lord is on her side (Ps. 118:6). She is not afraid to be vulnerable as she does the good things God has called her to. Her strength comes from the Lord, and His perfect love drives out her fear.

6. Being vocal

Sarah had a voice. She was actually quite vocal. While she was submitted to her husband, she was not silent. Her role in her marriage shows that she was not muzzled. The Lord even told Abraham, "Whatever Sarah has said to you, listen to her voice" (Gen. 21:12).

Modern-day Sarahs will not keep silent. They are not afraid to speak up, speak out, and speak the truth in love. They are voices of wisdom. They know the power of their words, so they use their voices for good. They speak words of life. Yes, modern-day Sarahs are submitted, but that does not mean they are silent.

7. Keeping the vision

Sarah was a visionary, and she kept Abraham and herself on task. She knew the covenant would be fulfilled through Isaac, but Ishmael posed a threat to that because he was stronger and manipulative. So she made a decision and followed through to keep everything on track. She was the keeper of the vision.

Modern-day Sarahs are also vision keepers. They keep the God-given vision ahead of them as they make decisions and commit to follow through with them. They keep the *why* of their decisions at the forefront. They are committed to the covenant relationships in their lives; they are committed to the promises they have made.

Hindrances to the Sarah Anointing

The modern-day Sarah is a woman of wisdom, courage, and vision, but the enemy will try to block or impede her fruitfulness and the fulfillment of God's vision for her as a mother of nations. The first step in overcoming the attacks is to identify the hindrances the enemy will try to use.

+ Hope deferred—God has given you a vision or a promise, but sometimes the fulfillment of that vision or promise is delayed. One of the biggest hindrances to the Sarah anointing is hope deferred. Proverbs 13:12 says, "Hope deferred makes the heart sick." Struggling with disappointment over a dream denied or promise postponed can hinder your ability to walk in the Sarah anointing.

+ Doubt and unbelief—Faith is vital to the Sarah anointing. Sarah had to go through a growth process to develop her faith. Doubt and unbelief hindered her early on, but her growing faith was able to overcome them. Doubt and unbelief can easily follow behind hope deferred.

+ Ishmael and the bondwoman—Ishmael and Hagar, the bondwoman, are both symbols of the flesh. They are reminders of what happens when you are impatient and don't wait on the promise of God. Giving in to your flesh and getting ahead of God will hinder the Sarah anointing. The bondwoman also attacked Sarah's womanhood, highlighted her barrenness, and bucked up against her authority.

+ Indecision—The inability to make and commit to a decision is a hindrance to the Sarah anointing. Sarahs need to be decisive, unwavering, and steady.

+ Having poor role models and mentors—Women need good role models and mentors, examples of women who lead well in their homes and in the marketplace. Women need to activate, teach, train, and equip other women. Having poor role models and mentors can lead to an incorrect understanding of what it means to be a godly woman.

> Likewise, teach the older women to be reverent in the way they live, not to be slanderers or addicted to much wine, but to teach what is good. Then they can urge the younger women to love their husbands and children, to be self-controlled and pure, to be busy at home, to be kind, and to be subject to their husbands, so that no one will malign the word of God.
>
> —Titus 2:3–5, NIV

* Bad definitions and examples of submission—One of the results of having poor role models is that we also often have a skewed understanding of what biblical submission is. Submission does not mean you are muzzled, without authority, without a voice, without an opinion, and without your own identity. It does not mean that you cannot use your gifts and pursue the vision God has given you. It does mean that we are submitted to one another and learn to lead in partnership.

How to Overcome Hindrances to the Sarah Anointing

The primary way to overcome hindrances to the Sarah anointing is to fully understand the Father's love. We are Daddy's girls, and He will fulfill every promise He made to us. When we get a revelation of the Father's great love for us, we can have faith. We can trust in His promises. We can know that He will heal the brokenhearted. We can trust in

God's supernatural power to redeem us and restore to us anything we lost because of religion or the traditions of men.

Once we understand the Father's amazing love for us, we can have hope, an expectation to see the goodness of God at work in our lives. While our hopes may have been disappointed or deferred in the past, God can heal our hope because He *is* hope.

God is more committed to seeing His promises fulfilled than we are. His love is different from human love. It is eternal. God has a strategy and a plan, and women were His idea. We are part of His plan. We need to yield to His plan, listen for His voice, and obey it. God said that if we love Him, we will keep His commandments (John 14:15). That's a good place to start.

The revelation of the Father's love for us also keeps us secure in our identity as daughters of the Most High. We have been accepted, redeemed, and renewed, so we don't have to try to be "enough" on our own. People with an orphan spirit try to perform, try to be good enough. But as daughters of the King of kings, we are already enough. We were made in His image and likeness. He has chosen us, rooted and grounded us in His love, and given us authority. And because of the great grace He has imparted to us, we can choose to walk in the Spirit, not giving in to the flesh. We can be bold, decisive, and courageous, knowing that the Lord will never leave us nor forsake us and that His plan for us is good.

When you are struggling with indecision and doubt, recommit to your covenant. The ancient Israelites often built

altars or had memorials to remind them of covenants and the great things God had done in their lives. They could revisit the memorials to make sure they never forgot. Revisit your covenant. Recommit to it. Keep the *why* of your covenant at the forefront.

Find godly mentors and role models who have strong, healthy marriages and display biblical submission. We all need mentors to pour into us, to give us wise counsel, to train us, and to equip us to be the women God has called us to be. Don't let religious views of submission silence you. You have a voice; use it with wisdom. God designed marriage to be a partnership. The Lord recognized Adam's need for a helper, someone to aid and protect him. A husband and wife are intended to protect each other; it is the nature of a wife to protect her husband, although in a different manner from how he protects her. And God told the man and woman to work together to have dominion and increase His kingdom on the earth.

Remember that you are in a growth process. There may be times when you fail, but don't give up and don't wallow in your failure. God is working in you to develop your faith. Don't let the attacks of the enemy or your own mistakes get in the way of your pursuit of God's plans and purposes for your life. Contend for the faith. Contend for the promises. You have been called to be a woman of God, a woman of hope, a woman of vision, a woman of faith that breaks through barrenness to fruitfulness, a mother of nations.

Prayer to Activate the Sarah Anointing

Lord, I believe You are the same yesterday, today, and forever. You are the unchanging God! I ask that You mantle me with the same tenacity and faith You gave Abraham and Sarah. I want to be fully persuaded in Your promises. Lord, take away any doubt and unbelief from my heart. I repent of having hardness of heart. I choose to take You at Your Word. You are not like man; You cannot lie. There is nothing too hard for You. You will bless me and make me a blessing to my generation. I will not lose hope in Your promises over my life. I choose to let hope be the anchor of my soul.

Lord, You are the giver and restorer of life. I ask that You restore every dream and desire from You that has died in my heart. Life-giving Spirit, flow within me once again! Let new ideas and concepts to advance Your kingdom fill my heart. I decree that I am a mother to this generation. I will pour my life into the next generation. I will be a woman of faith and empower a generation to believe You, Lord. I desire to fulfill the creation mandate to be fruitful and multiply.

Father, give me wisdom and right words. I declare I am a mother to the nations. I will give birth to spiritual children. I will give birth to new ideas. I will do good, and I will not fear. I will be a vision keeper. I will return to the ancient paths and be a blessing to the generations. Lord, in Your name, I will contend for the faith. Give me a fresh revelation of Your great love for me so that I can overcome any hindrances. I trust You. I hope in You. This I pray in the mighty name of Jesus. Amen.

Chapter 1

FAITH FOR YOURSELF

By faith Sarah herself also received strength to conceive seed,
and she bore a child when she was past the age, because she
judged Him faithful who had promised.

—HEBREWS 11:11

IT IS IMPORTANT to have faith for yourself. You can't depend
on the faith of your husband, your parents, your grandparents, your leaders, or anyone else. You have to develop your
own faith.

Hebrews 11:11 says, "By faith Sarah herself...." Although
Abraham was a man of faith, and his faith also played a role
in the fulfillment of God's promise, Sarah did not rely on
Abraham's faith. She had her own faith. She judged God as
faithful, and she believed He would keep His promise.

The Beginning of Faith

Where did Sarah's faith begin? She wasn't raised in church
as some of us were. She couldn't read a Bible or listen to a
sermon as we can do today. But her faith had a beginning,
and that beginning was God. I believe God creates each of

us with a desire to search for Him built into our DNA. The Book of Ecclesiastes says God has put eternity in our hearts (3:11). That longing for the eternal, the infinite, in our finite souls prompts us to seek God. And He put the evidence of His majesty and glory all around us.

> The heavens declare the glory of God; and the firmament shows His handiwork.
>
> —PSALM 19:1

> For since the creation of the world His invisible attributes are clearly seen, being understood by the things that are made, even His eternal power and Godhead.
>
> —ROMANS 1:20

Sarah was already being drawn by the Father through her very nature and through the wonders of creation, but she also married a man of faith. I believe she was very conscious of Abraham making offerings to God and the way God talked to him. And she took her first step of developing faith for herself when she left her home and her country to go with Abraham wherever God told them to go. While she may have been dependent on Abraham's faith at first, along the journey she found out about the faithfulness of God for herself. She saw the way God intervened for them when they made mistakes. She saw how He kept His promise. All these things drew Sarah to her Creator, and her heart responded. She "judged Him faithful who had promised" (Heb. 11:11). God had given her a measure of faith (Rom. 12:3), and she yielded to it.

Some people have an easier time yielding to God than others, but faith still always starts with God. Jesus said, "No one can come to Me unless the Father who sent Me draws him" (John 6:44). The Father draws us to Himself with His love. That is why understanding the great love of the Father for His daughters is so important to the Sarah anointing. You must have the revelation that "neither death nor life, nor angels nor principalities nor powers, nor things present nor things to come, nor height nor depth, nor any other created thing, shall be able to separate us from the love of God which is in Christ Jesus our Lord" (Rom. 8:38–39). You have a choice. You have free will. But God uses His lovingkindness to draw you because He is "not willing that any should perish but that all should come to repentance" (2 Pet. 3:9). When you respond to the Father's loving call, you will begin to develop faith for yourself.

Modern-day Sarahs have an advantage that Sarah did not have: the Word of God.

> So then faith comes by hearing, and hearing by the
> word of God.
>
> —ROMANS 10:17

To develop your faith, you need to have a personal relationship with God, and to develop a relationship with someone, communication is necessary. One of the primary ways God will speak to you is through His Word. You need to spend time reading and understanding the Word for yourself. Spending time in prayer and worship will also develop your relationship with God and grow your faith. The more time

you spend with the Lord, the more you will understand His love for you and the more you will be able to abide in His love.

> And now abide faith, hope, love, these three; but the greatest of these is love.
>
> —1 CORINTHIANS 13:13

> As the Father loved Me, I also have loved you; abide in My love. If you keep My commandments, you will abide in My love, just as I have kept My Father's commandments and abide in His love.
>
> —JOHN 15:9-10

Receive Strength

It is all too easy to rely on your own human strength, your own abilities. But to walk in the Sarah anointing, you need to receive strength from the Lord, supernatural strength that can break through any barriers to your receiving your promise.

Hebrews 11:11 says Sarah received strength because of her faith. The Greek word translated "strength" is *dynamis*. It means "virtue...strength, power, ability...power residing in a thing by virtue of its nature...power for performing miracles; moral power and excellence of soul; the power and influence which belong to riches and wealth; power and resources arising from numbers...miraculous power."[1] The word implies so much more than receiving the ability to conceive a child. Sarah received a supernatural impartation because of her faith, and that impartation went beyond a baby to include moral excellence and miraculous power.

The power of faith includes righteousness and moral

power. As Sarah's faith grew, she became steady, constant, and unwavering with moral excellence. Modern-day Sarahs do the same. We live in a generation where it seems as though anything goes, as if we should not put any kind of restrictions on ourselves. But righteousness and moral excellence are part of the power of faith, and to be a moral person there is some restriction. Daughters of Sarah do good and walk in righteousness out of obedience prompted by love. Modern-day Sarahs need to stay steadfast and committed to moral excellence, even when it seems as if no one is watching.

The meanings of the word *dynamis* are similar to those for the Hebrew word *chayil*, used in Proverbs 31 to describe the virtuous woman. We see many of the traits of the virtuous woman in Sarah: "The heart of her husband safely trusts her....Strength and honor are her clothing....She opens her mouth with wisdom, and on her tongue is the law of kindness....A woman who fears the LORD, she shall be praised" (vv. 11, 25–26, 30). But just as *dynamis* has multiple meanings, so too the *chayil* woman is not simply virtuous, although she is that. She is strong, powerful, and mighty, and she has the power to gain wealth and be a great force.[2]

Dynamis and *chayil* both come from faith in God. The Bible tells us that "faith is the substance of things hoped for, the evidence of things not seen" (Heb. 11:1). The Greek word for faith, *pistis*, means "conviction of the truth of anything, belief...a conviction or belief respecting man's relationship to God and divine things, generally with the included idea of trust and holy fervour born of faith and joined with it... the conviction that God exists and is the creator and ruler

of all things, the provider and bestower of eternal salvation
through Christ...persuasion...credence; moral conviction...
of the truthfulness of God...assurance."³ Modern-day Sarahs
have an absolute conviction that what God says is true. They
have an assurance that God will keep His promises. They
stand on the promises of God. And their faith gives them
the strength, miraculous power, excellence of soul, and moral
power to fulfill God's plans and purposes for them in the
earth.

The Prayer of Faith

And the prayer [that is] of faith will save him who
is sick, and the Lord will restore him; and if he has
committed sins, he will be forgiven. Confess to one
another therefore your faults (your slips, your false
steps, your offenses, your sins) and pray [also] for
one another, that you may be healed and restored
[to a spiritual tone of mind and heart]. The earnest
(heartfelt, continued) prayer of a righteous man
makes tremendous power available [dynamic in its
working].

Elijah was a human being with a nature such as
we have [with feelings, affections, and a constitu-
tion like ours]; and he prayed earnestly for it not
to rain, and no rain fell on the earth for three years
and six months. And [then] he prayed again and
the heavens supplied rain and the land produced its
crops [as usual].

—JAMES 5:15–18, AMPC

If you are a righteous woman, and I believe you are because we are made righteous through the blood of Jesus, I want you to wrap your mind around this simple thought: your prayers are powerfully effective when they are in agreement with God's will. It is your kingdom birthright to release the power of God through prayer. Your prayer avails much. Your prayers make available tremendous power that is dynamic in its working. Your prayers can heal the sick, open the heavens, and bring revival to the nations.

James 5:15–18 gives us keys to praying effective prayers of faith. Our prayers have to be earnest. Confession is a precursor to healing and restoration when you have made a false step or sinned. It is the prayer of a righteous man or woman that makes tremendous power available.

Praying the prayer of faith doesn't mean that we will receive an immediate answer. The prayer of faith allows us the spiritual space for God to develop within us a level of maturity before we receive the promise so we won't shipwreck. The prayer of faith helps us build the capacity for miracles.

When you pray the prayer of faith, you need to wait on God to answer. Not waiting long enough for God to answer will produce negative results. When Sarah didn't wait on God to fulfill His promise and instead tried to orchestrate the answer herself by telling Abraham to sleep with Hagar, the results were disastrous. Hagar became a source of trouble for Sarah. She challenged Sarah's authority and was a continual reminder of Sarah's own barrenness. The Bible says that Sarah "became despised in [Hagar's] eyes" (Gen. 16:4).

And Hagar gave birth to Ishmael, who was destined to be "a wild man" with his hand against everyone (Gen. 16:12).

Impatience is not the only thing that will get in the way of answers to prayers of faith. Being disobedient can also cause you to miss the appropriate timing of God, sometimes resulting in either a long wait or an unfulfilled prophecy. The complaining and disobedience of the children of Israel caused an entire generation (except for two men) to miss out on entering the Promised Land. Instead they wandered in the wilderness for forty years. (See Numbers 14.)

Modern-day Sarahs are women of faith and righteousness. They know that the prayer of a righteous woman makes tremendous power available. They wait on the timing of God, and if they take a wrong step, they are quick to confess and be restored.

Sometimes our prayers are hindered when we ask God for something amiss. We may ask God to make us fruitful for our own comfort, our own glory, or our own convenience.

> You ask and do not receive, because you ask amiss, that you may spend it on your pleasures.
>
> —James 4:3

The Greek word translated "amiss" means "badly (physically or morally):—amiss, diseased."[4] When you pray for something amiss, your focus is not in the right place, and more importantly, your heart is not in the right place. You have allowed your flesh to get in the way. Your focus is on what pleases you rather than what pleases God.

[handwritten marginalia: When you pray for something amiss]

[handwritten note at bottom: focus an heart are not in the right place]

Pray for what will please God

When Jesus taught us to pray, He said to pray in this manner:

> Our Father in heaven, hallowed be Your name. Your kingdom come. *Your will be done* on earth as it is in heaven. Give us this day our daily bread. And forgive us our debts, as we forgive our debtors. And do not lead us into temptation, but deliver us from the evil one. For Yours is the kingdom and the power and the glory forever. Amen.
>
> —MATTHEW 6:9–13, EMPHASIS ADDED

The prayer of faith is a prayer for God's will to be done. It's about what pleases God, what will bring about His purposes in the earth. That doesn't mean you can't talk to God about the desires of your heart. And that also doesn't mean you can't ask God for help. You are His daughter, and He wants you to share your heart with Him. He wants you to run to Him when you are hurting or in trouble.

> Let us therefore come boldly to the throne of grace, that we may obtain mercy and find grace to help in time of need.
>
> —HEBREWS 4:16

The difference between the prayer of faith and asking amiss is the end goal. Is it your will or God's will? Your plan or His plan? A woman with the Sarah anointing prays prayers of faith that are about bringing the will, plans, and purposes of God to bear in her life and in the earth, all for the glory of God.

Surrender Your Plans

Part of developing faith for yourself is learning to trust God instead of depending on yourself. It is looking away from your own abilities and toward God's faithfulness. Many of us say with our mouths that we trust God, but we are busy doing things in our own strength. Jesus said, "If anyone desires to come after Me, let him deny himself, and take up his cross daily, and follow Me" (Luke 9:23). Trusting God means dying to yourself. We must be intentional about surrendering our plans to God's plans.

Sarah had to learn this lesson. She had to learn to trust God, to have faith that He would fulfill His promises instead of trying to bring about the promised child on her own. When the fulfillment of a promise is delayed, God uses that time to train us in trust and intimacy. The Father purposely hides many details of life, including how He will bring deliverance in the face of our problems. Why does God do this? He wants us to have security in intimacy with Him rather than in having all the details of our future.

> Trust in the LORD with all your heart, and lean not on your own understanding; in all your ways acknowledge Him, and He shall direct your paths.
>
> —PROVERBS 3:5–6

Surrendering to God and acknowledging Him require us to use our lips and thoughts to cry out before the Lord. The word *acknowledge* is *yāḏaʿ* in the Hebrew. *Yāḏaʿ* also means to know, perceive, know by experience, distinguish,

or recognize. But *yāḏaʿ* can also refer to the act of physical intimacy between a man and a woman, the life-giving intimacy found in marriage.[5] When we look at it from a spiritual perspective, *yāḏaʿ* suggests having an intimacy with God through prayer that brings life, bears fruit, and gives birth to the fulfillment of His Word in our lives. When we maintain direct, intimate contact with the Lord, He will direct our paths according to His plans and purposes for us.

Modern-day Sarahs have this desire to acknowledge God in all their ways, to have intimacy with Him that produces fruitfulness in their lives. They have faith in God for themselves, and that faith is credited to them as righteousness (Rom. 4:11). The modern-day Sarah's heart moving to obey God is more righteous than the act of obedience itself. The desire to obey God means everything.

Passing on Your Faith

Modern-day Sarahs understand that while they must have faith for themselves, it doesn't stop there. The promise the Lord made to Abraham in Genesis 12 to make him a great nation (v. 2) extends to Sarah and her daughters, that is, to you and me and every other woman who has inherited Sarah's legacy of faith. While we all need to have faith for ourselves, we are also part of the family of faith. We are part of the promised great nation. We have a heritage of faith that has been passed down from generation to generation for thousands of years. We are part of the blessing of the Lord that has been extended from generation to generation.

Faith has been an inheritance given to both natural and spiritual children throughout the ages. We are the fruit of the promise. We are heirs of the promise.

The promise is bigger than any one individual. Having faith like Sarah means you have a bigger perspective. It is about building a family, building a legacy. It is about having faith for generations. It is about having faith for the nations and peoples that are the fruit of your life. Your family is not just "us four and no more." All of us, married or single, have families assigned to us. Yes, it includes your natural family, but it also includes all the spiritual family members God brings into your life. Daughter of Sarah, you are called to have faith for yourself, but you also are called to pass that faith on, to build a spiritual legacy that will bless the nations of the earth.

Declarations of Faith

I will have faith for myself.

I judge God faithful. I trust in His promises.

"Neither death nor life, nor angels nor principalities nor powers, nor things present nor things to come, nor height nor depth, nor any other created thing, shall be able to separate [me] from the love of God which is in Christ Jesus [my] Lord" (Rom. 8:38–39).

I will abide in God's love and keep His commandments.

I will receive strength from the Lord.

I will walk in righteousness.

I am a woman of moral excellence.

Strength and honor are my clothing.

I open my mouth with wisdom.

Kindness is on my tongue.

My faith is the substance of things hoped for, the evidence of things not seen.

I stand on the promises of God.

When I confess my sins, I will be forgiven and restored.

I am a righteous woman, and my prayers are powerfully effective.

I wait on the Lord to answer my prayers.

I do not ask amiss when I pray. I pray for God's will to be done on earth as it is in heaven.

I go boldly to the throne of grace to obtain mercy and find grace to help in time of need.

I surrender my plans to Jesus.

I trust in the Lord with all my heart, and I acknowledge Him in all my ways.

I will pass on a heritage of faith to my natural and spiritual children.

I am building a legacy of faith.

Chapter 2

THE POWER OF YOUR
EVERYDAY DESIRES

Delight yourself also in the LORD, and He shall give you the desires of your heart.

—PSALM 37:4

YOUR EVERYDAY DESIRES can be powerful, leading to something much bigger than you ever imagined. When God appeared to Abraham and made a covenant with him, Sarah wasn't thinking about being legendary. She probably never even dreamed of being the mother of nations. She just had a regular, normal, everyday desire: to have a baby. And because of her age, she had probably dismissed that desire or tried to stuff it down deep inside her as a desire that would never be fulfilled. She may have even experienced a certain amount of brokenness over her barrenness.

But God had big plans for Sarah. He was going to take her everyday desire of everyday life and transform it into something great.

The Desires of Your Heart

You were created for a purpose. God designed you specifically to be able to fulfill His purpose for you in the earth.

> For You formed my inward parts; You covered me in my mother's womb. I will praise You, for I am fearfully and wonderfully made; marvelous are Your works, and that my soul knows very well. My frame was not hidden from You, when I was made in secret, and skillfully wrought in the lowest parts of the earth. Your eyes saw my substance, being yet unformed. And in Your book they all were written, the days fashioned for me, when as yet there were none of them.
>
> —PSALM 139:13–16

You were fearfully and wonderfully made—body, soul, and spirit—with God's plan for you in mind. Nothing about you is an accident, from the color of your eyes to your natural gifts and talents to the things that draw your heart. You have a purpose, a God-given purpose that only you can fulfill. But I believe that understanding your purpose often starts with the everyday desires God puts in your heart. I believe those desires are the starting point, the place where God begins drawing you closer to His plan and purpose for you.

Psalm 37:4 says, "Delight yourself also in the LORD, and He shall give you the desires of your heart." I believe this verse means that when you delight yourself in the Lord, He will implant desires in your heart that align with His purpose for you. He will awaken some desires that were already

there or change other desires, all to spur you on toward fulfilling His good plan for you. Your everyday desires are the place where everything starts.

A desire is something you long for, something you hope for. The Hebrew word used for it in Psalm 37 is *miš'ālâ*, which means request, desire, or petition.[1] Other than Psalm 37:4, *miš'ālâ* is used only one other time in the Bible, translated as "petitions":

> We will rejoice in your salvation, and in the name of our God we will set up our banners! May the Lord fulfill all your petitions.
>
> —Psalm 20:5

Both verses are about God hearing and answering our prayers. And the truth is that God knows our desires, our petitions, our requests before we even ask Him.

> O Lord, You have searched me and known me. You know my sitting down and my rising up; You understand my thought afar off. You comprehend my path and my lying down, and are acquainted with all my ways. For there is not a word on my tongue, but behold, O Lord, You know it altogether.
>
> —Psalm 139:1–4

God knows you. He understands your thoughts, your ways. And He understands those everyday desires in your heart because when you have delighted yourself in Him, He is the One who put them there.

Sarah's desire for a baby was one of those everyday desires,

and it was where everything started for her. God took that desire to give birth and used it to turn Sarah into the mother of nations and a woman of legendary faith.

Sarah also desired righteousness. She didn't just want to be right; she wanted to be righteous. That is why she submitted to her husband. Imagine the pain she must have felt when in both Egypt and Gerar Abraham lied and said Sarah was his sister. She ended up in a harem twice because her husband wasn't willing to fight for her. Because of his own selfishness, he put her in the position of possibly having to sleep with someone else. If Sarah just wanted to be right, she would have told Abraham, "I'm not doing that! Are you crazy?" But she wanted to be righteous, and because of that righteousness God intervened in a supernatural way both times to save her, sending plagues to Egypt and speaking to the king of Gerar in a dream. God fights for His daughters. He defends them. When Sarah's heart—her desire—was to do the righteous thing, God moved in to manifest miracles on her behalf.

Another of Sarah's desires was to please and honor God. She kept reminding Abraham of the vision. And even though she messed up by telling Abraham to sleep with Hagar to produce a child, the intent behind it was to see the promise of God fulfilled.

> So Sarai said to Abram, "See now, the Lord has restrained me from bearing children. Please, go in to my maid; perhaps I shall obtain children by her."
> —Genesis 16:2

Sarah offering the bondwoman to Abraham was an act of self-sacrifice, even though it was misguided. Imagine how she must have felt as she lay in bed alone while her husband was with another woman. And then when that woman got pregnant, it confirmed that Sarah and not Abraham was the reason they had not had a child. She knew for sure it was her. She was the one who needed a miracle. But still Sarah had acted in an attempt to please and honor God, even though it was to her own detriment. We must always remember that heaven or hell can be in our desires.

As a modern-day Sarah, you may have similar desires. You may desire to give birth (whether in the natural, the spiritual, or both), to be righteous, and to please and honor God. The other everyday desires of your heart are just other pieces of the plan God has for your life.

Finding Where You Fit

We live in a time when so many people are crying out to find their purpose. They want to know where they fit in. They want to find meaning in their lives. But trying to find purpose and meaning in what the world labels success is meaningless. True success is found somewhere else.

To find meaning in life, you have to understand God's purpose for you. We all have a part to play in the family of God. You were chosen by God to be part of His family, part of the body of Christ, before the foundation of the world. You are chosen. You are accepted. You are blessed.

> Blessed be the God and Father of our Lord Jesus
> Christ, who has blessed us with every spiritual
> blessing in the heavenly places in Christ, just as He
> chose us in Him before the foundation of the world,
> that we should be holy and without blame before Him
> in love, having predestined us to adoption as sons by
> Jesus Christ to Himself, according to the good plea-
> sure of His will, to the praise of the glory of His grace,
> by which He made us accepted in the Beloved.
>
> —Ephesians 1:3–6

As a daughter of God, you need to find your place in the family. You need to find where you fit, your wonderful place. You need to discover your purpose. You need to know where your place is to serve the body of Christ and advance the kingdom of God by doing what God designed you to do. God gives every person work to do, an assignment. You are anointed for that assignment, and that means God's power to feel something, to desire something, is connected to your assignment.

You need to identify your desires and give them appropriate attention. Many of us have had our desires belittled, and because of that discouragement we don't look any deeper into whatever those desires are. But if God has awakened desires in your heart, you need to pay attention to them.

I always had a desire to be on the stage performing something. At first I thought it would be in the arts, as I was a dancer. I was also creative and wrote poetry. I also had a desire to teach, whether it was art or music or something else. But at the time I didn't know that all of those things were really just part of my purpose to be a preacher. My purpose is

to minister and present God to the world. All those desires I had were just leading me to and preparing me for it.

It is also important to recognize that there are times and seasons for your purpose. They are all part of your growth process. No matter what stage of the process you are in, relax and enjoy it. If you are in a waiting season, use the time wisely. Don't keep trying to run ahead of God in an attempt to hit some imaginary mark. Rest in the Lord, embrace who you are, and wait for the appointed time.

When I was in my thirties and my daughter was in high school, it was a season for me to be a mother instead of being on the front line, preaching and teaching. In that season I got to teach, train, activate, and cultivate my daughter as an individual. I had to settle within myself that I was not outside of my purpose. Pouring into my daughter was my purpose during that season. But I needed to discern that so I wouldn't view raising my daughter as a sidebar.

There are different ways your desires can be identified. Look back to your childhood and the dreams you had. A lot of the things from our childhoods are pure; those dreams may have been your safe place, the things that kept you going. Ask the Lord to remind you of those things, the desires He planted in your heart as a child.

Sometimes you may hear a direct word from God that awakens your desires. Prophecy awakens desires in us as well. Sometimes God will quicken a scripture to your heart. The Holy Spirit will lead you and guide you. God may also give you a dream or a vision.

When God has awakened a desire in your heart, the first

step is to validate that desire and your gifts and talents that go along with it. Don't get talked out of pursuing the God-given desires of your heart by family members or dream stealers.

Don't Lose Your Grip!

Modern-day Sarahs need to passionately pursue God's plans and purposes for their lives without letting dream stealers get in the way. If God has placed a dream in your heart, you need to be confident in your ability to follow it to fruition in your life. You are called to fruitfulness, whether natural or spiritual, and you cannot let the enemy get in your way.

Hebrews 10:22–25 says:

> Let us draw near with a true heart in full assurance of faith, having our hearts sprinkled from an evil conscience and our bodies washed with pure water. Let us hold fast the confession of our hope without wavering, for He who promised is faithful. And let us consider one another in order to stir up love and good works, not forsaking the assembling of ourselves together, as is the manner of some, but exhorting one another, and so much the more as you see the Day approaching.

Daughter of Sarah, you need to hold fast, knowing that the One who awakened desires in your heart is faithful. The Greek word translated "hold fast" means to "hold down, keep, retain, possess, seize, keep firm possession of, keep secure,

and hold back from going away."[2] In other words, don't lose your grip on your dreams!

To keep your grip on your dreams, you need to be aware of the dream stealers and their tactics, as well as how to defeat them. One dream stealer is time. When God has given you a dream or vision, but a long time passes and it has still not come to pass, you can get discouraged. The passage of time gnaws away at your faith, your perseverance, and your passion. Your soul may be tempted to rise up and question the integrity of God Himself when you wait and wait and wait. But you must remember that there is an appointed time for your dream to be fulfilled, and God is faithful. He gave you a specific promise in His Word just for times like this:

> ...being confident of this very thing, that He who has begun a good work in you will complete it until the day of Jesus Christ.
>
> —PHILIPPIANS 1:6

God is going to finish what He started in your heart. The key to defeating the dream stealer of time is remembrance. Remember God. Remember the experience you had when He gave you the promise. Remember that He is faithful. Remember that waiting time is just part of your growth process. Remember His promises. Remember all the times He has come through for you before. Remember, and wait for the appointed time.

> Therefore humble yourselves under the mighty
> hand of God, that He may exalt you in due time.
>
> —1 PETER 5:6

Another dream stealer is Satan and his lies. Satan will use anything he can to get you off track when you are in pursuit of your dream and God's purposes for your life. Don't let him. Don't lose your grip!

Satan will put all kinds of temptations in your path. He will fill your head with lies: a little compromise won't hurt because God will forgive me; I can allow this particular sin back into my life while I'm waiting because God's mercy will cover it; this little bit of disobedience is OK because of God's grace. Don't abuse God's grace, mercy, and forgiveness by allowing sin to come back into your life. When you let the enemy affect the way you think, you begin to draw back, and living that way for an extended period of time is dangerous. Sin will open the door for death to invade your life. The key to defeating the lies of the enemy is to take those thoughts captive:

> ...casting down imaginations, and every high thing
> that exalteth itself against the knowledge of God,
> and bringing into captivity every thought to the
> obedience of Christ.
>
> —2 CORINTHIANS 10:5, KJV

God has given you a very powerful weapon: His Word. When the enemy comes to steal your dreams with his lies, you fight back with the sword of the Spirit. Wield the truth

like the fierce warrior of God you are, and don't give the lies a chance to take root in your heart.

Dream stealers are unfortunately often found in your own family as well. Your family is a powerful influence in your life, and their negativity can stop you from moving forward in faith. Family members may speak words of doubt and discouragement over your desires and dreams: "That will get you nowhere," "You're not capable of that," or "That's not going to do anything for you." That is why God sometimes calls you away from your family, just as He did with Abraham and Sarah when He called them to leave their home and their country and go to a place He would show them. It may mean physically relocating, or it may just mean disconnecting from their mindset, the negative mentality that stifles your desire to do what God has called you to do.

Dream stealers also may include doubt, unbelief, fear, and other things. But ultimately the key to defeating any dream stealer is to walk by faith, not by sight (2 Cor. 5:7). God is at work behind the scenes, making even the greatest disappointments, frustrations, challenges, and setbacks of life work for your good. God promises that "all things work together for good to those who love God, to those who are the called according to His purpose" (Rom. 8:28).

Modern-day Sarahs firmly embrace God's plan for their lives. Even when dream stealers try to cause doubt, disappointment, or despair, the daughters of Sarah will rise up in faith to boldly pursue the desires of their hearts, awakened by the Lord God Almighty for such a time as this. They will

hold fast to the promises of God, and they won't lose their grip.

Be You

When it comes to dreams and desires, you need to embrace who you are. God didn't make a mistake when He gave you the desires of your heart, so don't get distracted by the desires of others. Sometimes we can get into competition with others when it comes to our desires and how they take shape. We may think we need to look at other people and see how they are pursuing their purposes to make sure we win some imaginary race to the finish. Your purpose is yours alone. You are not in competition with anyone. Sarah recognized that. She was not competing with anyone, even Hagar. She was confident in who she was and the plan God had for her.

You need to be authentically you, the you God created you to be, rather than trying to be someone else or trying to meet someone else's expectations of who you should be. You are God's workmanship, created exactly the way He wanted for all the good things He prepared for you to do (Eph. 2:10).

You have the power to change the world, but it starts with you being authentically you. You don't need to try to do something spectacular out of your own strength. You have been supernaturally equipped to fulfill God's purposes for you in the earth. That's how God created you—you are naturally supernatural. Have confidence in the way you were created and in the dreams and desires God has placed in your heart. God will lead you through. Keep walking by faith.

Prayer About Everyday Desires

Lord, I choose to delight myself in You so You will give me the desires of my heart. You created me for a specific purpose, and the desires You put in my heart are there for a reason. I pray that You will bring back to my remembrance the desires You placed in my heart that fell victim to dream stealers. Help me to desire righteousness more than I desire to be right. Help me to desire to please and honor You above all else.

Lord, I pray that You will show me where I fit, where my place is in Your family. I know I am blessed, chosen, and accepted, but I need to discover my purpose and the place where I can serve You and advance Your kingdom. Anoint me for my assignment. I choose to rest in You and wait for the appointed time. I will hold fast to the dreams and desires You have placed in my heart. I will remember Your goodness, and I will defeat the lies of the enemy with the truth of Your Word.

Thank You that I am fearfully and wonderfully made. I choose to be exactly who You created me to be. Help me to walk in the good deeds You prepared for me. I know You are working all things together for my good, and I praise You for it. Thank You, Jesus! Amen.

Chapter 3

BUILDING CAPACITY
FOR MIRACLES

Enlarge the place of your tent, and let them stretch out the curtains of your dwellings; do not spare; lengthen your cords, and strengthen your stakes. For you shall expand to the right and to the left, and your descendants will inherit the nations, and make the desolate cities inhabited.

—Isaiah 54:2–3

We all go through a growth process with our faith. Faith is like a seed planted in your heart. As you nourish and water it with the Word, it starts to grow and develop, sending roots down deep into your soul and producing fruit in your life. Part of that growth process is building your capacity for miracles.

Perception

Building capacity starts with perception. Perception is defined as "the way you think about or understand someone or something; the way that you notice or understand something using one of your senses...quick, acute, and intuitive cognition: appreciation; a capacity for comprehension."[1] Depth

perception is "the ability to judge the distance of objects and the spatial relationship of objects at different distances."[2]

We all have perception and depth perception in the natural, but we need spiritual perception as well. With the Sarah anointing, you must have foresight and the ability to see the promise from God's perspective. You need to allow the Holy Spirit to adjust how you think about or understand things and to give you the capacity to comprehend how God is at work in your life to fulfill His promises. You also need spiritual depth perception to be able to see the relationship between all the different pieces of God's plan and how they are working together to accomplish God's purpose for you in the earth.

Sarah's perception changed when she judged God as faithful. She focused on the person behind the promise rather than the promise itself. It is vitally important that faith not be separated from God. Second Timothy 1:12 says, "For I know whom I have believed and am persuaded that He is able to keep what I have committed to Him until that Day." God is able. The word translated *able* in that verse means "mighty in wealth and influence," powerful, mighty, and strong. It also means to have the power to do something.[3] Modern-day Sarahs must exchange their strength for His strength, their inabilities for His ability and power.

Sometimes when God first speaks to us, our perception is flawed. But then God may give us a dream or a vision or speak to us in another way to help us understand.

> I will answer you, for God is greater than man. Why
> do you contend with Him? For He does not give an
> accounting of any of His words. For God may speak
> in one way, or in another, yet man does not perceive it.
> In a dream, in a vision of the night, when deep sleep
> falls upon men, while slumbering on their beds, then
> He opens the ears of men, and seals their instruc-
> tion. In order to turn man from his deed, and con-
> ceal pride from man, He keeps back his soul from
> the Pit, and his life from perishing by the sword.
>
> —Job 33:12–18

This is what happened to Abraham and Sarah. They received the promise, but they didn't perceive it. So God spoke to them again and again. God gave the initial promise to Abraham when he was still in his home country. Then the Lord appeared to Abraham again in Canaan and told him He would give the land to Abraham's descendants. Then the Lord spoke to Abraham again after he separated from Lot. I am sure that Abraham shared all the things the Lord spoke to him with Sarah. And while they understood the promise, their perception was still flawed, for when the Lord appeared again to Abraham, this time in a vision, Abraham told Him, "Lord God, what will You give me, seeing I go childless, and the heir of my house is Eliezer of Damascus?…Look, You have given me no offspring; indeed one born in my house is my heir!" (Gen. 15:2–3).

The Lord had spoken in one way and then another, but still Abraham and Sarah did not perceive the truth behind God's promise. So the Lord spoke to Abraham in a vision of

the night. He brought Abraham outside to look at the stars, telling him, "Look now toward heaven, and count the stars if you are able to number them....So shall your descendants be" (Gen. 15:5). And the Lord wasn't finished yet. He appeared to Abraham again as a burning torch that passed between the pieces of Abraham's sacrifice, confirming His covenant with him. Then years later the Lord appeared to Abraham yet again, repeating His promise and specifically including Sarah in the plan this time.

This is why we need to ask the Holy Spirit to give us spiritual perception. Yes, God will make sure we understand His promise to us, but we often run into trouble when we fail to perceive it correctly at first. If Abraham's and Sarah's perception of the promise had been correct from the beginning, many of the problems they faced could have been avoided. When you receive the promise, ask for the grace to perceive it.

In this season, there is a lot of heavenly activity to help us birth the next move of God. Just as God used angelic visitations, dreams, visions, and miracles to push Abraham and Sarah toward their destiny, He is doing the same today. God is moving and sending forth His Word and His angels to help us correctly perceive the promise. God is sending us help from the sanctuary to aid us as we push toward fulfilling our destinies.

Making Room

Capacity is defined as "the ability to hold or contain people or things...the ability to do something: a mental, emotional,

or physical ability."[4] Modern-day Sarahs need to have the capacity for their miracles. This is part of their growth process, just as it was for Sarah.

The first step in making room and building your capacity is to get rid of the old to make room for the new. It's like when you survey the clothes in your closet because you want to renew your wardrobe, refresh your look, and change up the way you present yourself. To make room for the new clothes, you have to get rid of the old.

To build your capacity for miracles, you need to renew your mind. You need to get rid of the old way of thinking, the old thought patterns, and the old hang-ups that were part of the old you. You are a new creation in Christ; all things have become new.

> Therefore, if anyone is in Christ, he is a new creation; old things have passed away; behold, all things have become new.
>
> —2 Corinthians 5:17

> Put off, concerning your former conduct, the old man which grows corrupt according to the deceitful lusts, and be renewed in the spirit of your mind, and that you put on the new man which was created according to God, in true righteousness and holiness.
>
> —Ephesians 4:22–24

> You have put off the old man with his deeds, and have put on the new man who is renewed in knowledge according to the image of Him who created him.
>
> —Colossians 3:9–10

When the old thoughts jump into your brain, especially the lies of the enemy that tempt you to fall back into sin, you need to take them captive to the obedience of Christ and replace them with the truth of the Word.

> For the weapons of our warfare are not carnal but mighty in God for pulling down strongholds, casting down arguments and every high thing that exalts itself against the knowledge of God, bringing every thought into captivity to the obedience of Christ.
>
> —2 CORINTHIANS 10:4–5

Once you have gotten rid of your old mindsets and replaced them with new ones based on the truth in the Word of God, it's time to expand.

> "Sing, barren woman, who has never had a baby. Fill the air with song, you who've never experienced childbirth! You're ending up with far more children than all those childbearing women." GOD says so! "Clear lots of ground for your tents! Make your tents large. Spread out! Think big! Use plenty of rope, drive the tent pegs deep. You're going to need lots of elbow room for your growing family. You're going to take over whole nations; you're going to resettle abandoned cities. Don't be afraid—you're not going to be embarrassed. Don't hold back— you're not going to come up short. You'll forget all about the humiliations of your youth, and the indignities of being a widow will fade from memory. For your Maker is your bridegroom, his name,

God-of-the-Angel-Armies! Your Redeemer is The
Holy of Israel, known as God of the whole earth."
 —Isaiah 54:1–5, msg

Daughter of Sarah, it's time to expand! Break those walls
down, add an extension, and make more room because you
are going to need it. Sarah was called to be the mother of
nations, and modern-day Sarahs are called to be the same.
Abraham and Sarah wanted a child, and initially their per-
spective didn't go much beyond that. They didn't know the
extent of God's plan or how many generations God would
bless because of their faith and trust in Him. But their one
act of obedience had a much bigger effect on humanity than
they ever could have imagined.

As a modern-day Sarah, you can be assured that God's
plan for you will have far-reaching effects. God's ways and
thoughts are different from ours, so we need to be prepared
for something bigger than we dreamed.

"For My thoughts are not your thoughts, nor are
your ways My ways," says the Lord. "For as the
heavens are higher than the earth, so are My ways
higher than your ways, and My thoughts than your
thoughts."

 —Isaiah 55:8–9

Women with the Sarah anointing receive supernatural
strength to be a blessing to generations. God is imparting and
activating a supernatural anointing in you to give birth to your
dreams. Modern-day Sarahs will receive divine enablement to
equip, teach, and train the next generation. God is imparting

faith in women to give birth to our instinct to create, nurture, and invest in the life of another. The Sarah anointing is not limited to natural and physical childbearing and child rearing. We birth lives and ideas, cures, solutions, strategies, and entire movements. That is why you need to expand.

Again, while the Sarah anointing can apply to physical children, it is ultimately about spiritual children and passing the heritage of faith down from one generation to the next. As a daughter of Sarah you have received a mother anointing as a spiritual grace. If you are married, that grace is for both your natural and spiritual children. If you are single, remember that your Maker is your husband; the spiritual grace to mother is just as much yours as it is the married woman's. Keep in mind that the passage in Isaiah 54 says that the woman who doesn't give birth will have more children than the woman who does. Your singleness, whether just for a season or not, is part of God's plan. Don't let the enemy try to tell you that you are of lesser worth for the work of the kingdom just because you don't have a ring on your finger.

God is using women, both married and single, and will continue to use them to pour into the next generation. Then the women of the next generation will pour into the generation that follows them and on down the line until God's kingdom purposes are fulfilled in the earth. The greater capacity you have, the more you can pour into others, growing and nurturing the spiritual children God has given you.

While you may have been barren, God is empowering you as a modern-day Sarah to take over whole nations and

resettle abandoned cities with your spiritual children. It doesn't matter if you have been barren up until now. The nations were already in Sarah, even when she was barren. You may have dropped the ball when it comes to birthing spiritual children, but you can pick it back up again. There is a cry coming from the future, from your spiritual bloodline, crying out for you to birth something in the earth that will carry on from generation to generation. The nations are in you, even if you are barren. If you don't fight and use your gifts, the generations in your bloodline could be lost. So contend for the faith! Contend for your promises!

Modern-day Sarahs are being equipped to proclaim the Word, bring change, give hope, encourage others, and make a difference in the world both for this generation and the generations to come, all to further the kingdom of God and for His glory.

> The Lord gave the word; great was the company of women who proclaimed it.
>
> —Psalm 68:11, mev

Building Character to Hold the Bigger Promise

So how do you get ready for the big things God has for your life? Prophetic words of edification and encouragement that build you up are blessings and can really stir your heart, but building your capacity starts with building your character. Your everyday actions, how you respond to people in everyday encounters, how you make decisions, how you respond to conflict, how you respond to success and promotion—these

are the kinds of things that demonstrate your character. Do your everyday actions show the fruit of the Spirit or the works of the flesh?

> Now the works of the flesh are evident, which are: adultery, fornication, uncleanness, lewdness, idolatry, sorcery, hatred, contentions, jealousies, outbursts of wrath, selfish ambitions, dissensions, heresies, envy, murders, drunkenness, revelries, and the like....But the fruit of the Spirit is love, joy, peace, longsuffering, kindness, goodness, faithfulness, gentleness, self-control.
>
> —GALATIANS 5:19–23

No one expects you to be perfect. Sarah wasn't perfect, but she learned from her mistakes and continued growing, continuing her transformation process. When you sin, when you make a mistake, when you fail, don't waste your time throwing pity parties. Instead learn from your experience and keep moving forward. Look to the Word and the example of Jesus to define your core values. Imitate Jesus. Become more like Him every day. Be a woman of faith, righteousness, humility, and wisdom. Remember, anyone who has done anything great for God in any area of his or her life has sweated, sacrificed, fallen down, and stumbled before seeing success.

Chosen for a Miracle

There is a difference between a blessing and a miracle. When we see the miracles of God, we stand in awe and wonder at how marvelous He is, but if you really think about it, no one

wants to be in a situation where she needs a miracle. Needing a miracle is not an easy place to be. When you need a miracle, you are in a place of desperation, brokenness, and despair, in dire need of the mercy of God. Do you really want to be there? Of course not. So choose to live in the blessing of the Lord. God's ultimate plan was always to make us a blessing so all the nations of the earth can be blessed.

Be a woman who walks in communion with God, with His goodness overflowing in your life. God wants you to live at peace with Him, yourself, and others. He wants you to be filled with His peace that passes all understanding. He wants you to wake up every morning with the knowledge that His mercies are new and be filled with the joy of the Lord, which is your strength. He wants to bless you.

> The LORD bless you and keep you; the LORD make His face shine upon you, and be gracious to you; the LORD lift up His countenance upon you, and give you peace.
>
> —NUMBERS 6:24–26

When you are living in the blessing of the Lord, spending time in communion with Him, growing in the Word, and walking in righteousness with the help of the Holy Spirit, you are being a good steward of the promise. You are preparing yourself, building your capacity for miracles, because even when living in the blessing of God, the time may come when you need a miracle, and you need to be ready for it.

God chooses women with a heart for Him to be the recipient of miracles. When we look at the women in the Bible who

had children through miraculous, supernatural means, we see a pattern. Elizabeth was "righteous before God, walking in all the commandments and ordinances of the Lord blameless" (Luke 1:6). Mary was "highly favored...[and] blessed... among women" and "the maidservant of the Lord" (Luke 1:28, 38). Hannah "poured out [her] soul before the LORD" (1 Sam. 1:15). And Sarah, despite her mistakes and challenges, showed that she was a woman of faith. Despite the impossibilities in the natural, despite the fact that all reason spoke against God's promise, despite the fact that nature had to be overridden, Sarah moved from unbelief to belief, and she trusted God. With the exception of Mary, all the women I just listed had to deal with the pain of barrenness. They all had to deal with social ridicule. But their painful circumstances had nothing to do with their own sin. Instead, their circumstances were orchestrated so the glory of God could be revealed.

God works all things together for your good. That is a promise you can stand on when you need a miracle, when you are waiting for the fulfillment of the promise. When you have been chosen for a miracle, God will make you a vessel for His glory.

One time Jesus passed a man who had been blind from birth, and someone asked Him who had sinned to cause the man to be born blind. Jesus answered:

> Neither this man nor his parents sinned, but that the works of God should be revealed in him.
>
> —JOHN 9:3

The word translated "works" means toil, deed, effort, enterprise, business, occupation, and undertaking.[5] When Jesus walked the earth, He went about the Father's business. The things He did and the miracles He performed were all part of God's plan. The man born blind needed a miracle. He was chosen for a miracle. And that miracle brought glory to God.

But there is often a waiting time for the miracle. During the waiting time, we need to trust that the wait is part of the plan. We need to use that waiting time wisely, preparing ourselves to be vessels of the promise. God will give you endurance for the waiting. He will empower you to wait. So don't jump ahead and take the cake out of the oven before it is finished. You have been chosen. God will keep His promise to you. "Rest in the Lord, and wait patiently for Him" (Ps. 37:7).

Declarations About Building Capacity for Miracles

I will build my capacity for miracles.

I have spiritual perception and depth perception.

God speaks to me in dreams and visions to help me understand.

I receive the promise, and the Holy Spirit gives me grace to perceive it.

I renew my mind with the Word of God.

I am a new creation in Christ. Old things have passed away. All things have become new.

I put off the old man and put on the new man.

I will enlarge the place of my tent and strengthen my stakes. I will expand to the right and to the left, and my descendants will inherit the nations.

I have a mother anointing as a spiritual grace.

I will pour into the next generation. I will nurture the spiritual children God has given me.

The Lord gave the word, and I will proclaim it.

I learn from my mistakes and keep moving forward.

I am a woman of faith, righteousness, humility, and wisdom.

I have been chosen for a miracle.

I choose to live in the blessing of the Lord.

I walk in communion with God.

I am filled with the joy of the Lord, which is my strength.

God works all things together for my good.

I am a vessel for God's glory.

Chapter 4

THE POWER OF THE HELPMEET

And the Lord God said, "It is not good that man should be alone; I will make him a helper comparable to him."

—Genesis 2:18

From the dawn of creation, God recognized that it was not good for man to be alone. God had created man and put him in a beautiful garden to tend, but there was something missing. But God had a plan.

> The Lord God caused a deep sleep to fall on Adam, and he slept; and He took one of his ribs, and closed up the flesh in its place. Then the rib which the Lord God had taken from man He made into a woman, and He brought her to the man.
>
> And Adam said: "This is now bone of my bones and flesh of my flesh; she shall be called Woman, because she was taken out of Man."
>
> Therefore a man shall leave his father and mother and be joined to his wife, and they shall become one flesh.
>
> —Genesis 2:21–24

God created "a helper comparable" to Adam (Gen. 2:18). The Hebrew word for *helper comparable to*, or *help meet* in the King James Version, is ʿēzer, which means helper or succor and comes from a root word meaning to surround, protect, aid, and help.[1] It implies someone who has the capacity to rescue. Women were created to be helpers. It is part of our nature.

Characteristics of a Helpmeet

While being a helper is part of your nature, to be the kind of helpmeet God designed you to be, you need to know the characteristics of a godly helpmeet. There is no better place to look for that than to the Holy Spirit, because the Holy Spirit is the Helper. Near the end of His life on earth, Jesus promised His disciples:

> The Helper, the Holy Spirit, whom the Father will send in My name, He will teach you all things, and bring to your remembrance all things that I said to you.
>
> —JOHN 14:26

The Holy Spirit is our example of how to be a helper, but He also teaches us and empowers us to help. The Holy Spirit is the Counselor and Comforter; the Spirit of wisdom and understanding, counsel and might, and knowledge and the fear of the Lord; the Spirit of adoption; the Spirit of grace; and the Spirit of truth (John 14:16, AMP; Isa. 11:2; Rom. 8:15; Heb. 10:29; John 14:17).

A godly helpmeet models these characteristics. She encourages, exhorts, edifies, comforts, counsels, and understands. She is full of wisdom, grace, and truth. She has a voice, and she uses that voice wisely. She knows that death and life are in the power of her tongue, so she chooses her words carefully, knowing that the things she says could affect someone's ability to walk in the promise. Because of her maturity, she is able to have a meek and quiet spirit. She knows the power she carries, but that power is under control.

Eve was the very first woman to be a helpmeet. When we compare Sarah and Eve, we see very different pictures. Sarah followed her husband, but Eve led her husband to destruction.

> Now the serpent was more cunning than any beast of the field which the LORD God had made. And he said to the woman, "Has God indeed said, 'You shall not eat of every tree of the garden'?"
>
> And the woman said to the serpent, "We may eat the fruit of the trees of the garden; but of the fruit of the tree which is in the midst of the garden, God has said, 'You shall not eat it, nor shall you touch it, lest you die.'"
>
> Then the serpent said to the woman, "You will not surely die. For God knows that in the day you eat of it your eyes will be opened, and you will be like God, knowing good and evil."
>
> So when the woman saw that the tree was good for food, that it was pleasant to the eyes, and a tree

desirable to make one wise, she took of its fruit and
ate. She also gave to her husband with her, and he ate.

—GENESIS 3:1–6

Eve receives a lot of criticism for her role in the fall of
man, but I think there is more to this story than some might
think. Scripture is clear that Eve was deceived (1 Tim. 2:14).
It is also clear that Adam was not deceived, but he chose to
eat the fruit anyway. The Lord had given the instructions
to Adam about the tree of the knowledge of good and evil
before Eve was even created. We know that Eve knew about
the instructions because of what she told the serpent, but we
also know she didn't have her facts straight. God had said,
"Don't eat," but Eve said that God said, "Don't eat or touch."
And we know from Genesis 3:6 that Adam was with Eve the
whole time she was talking to the serpent. He heard that Eve
didn't have her facts straight, he heard the serpent deceiving
her, and he knew the truth, but he didn't intervene. In fact,
he followed right along.

Even though Eve was deceived, I believe she was sincere
in her desire to help. When the serpent told her they could
be like God, she thought that sounded like a good thing.
And I think the reason Adam didn't speak up was because it
sounded good to him too. They didn't understand that they
were already like God. So when Eve ate the fruit and then
offered it to her husband, I believe she thought she was doing
the right thing. She was still operating in her role as helper,
trying to make things better for herself and her husband.

In contrast, Sarah followed her husband. She submitted

to his leadership, even when I'm sure her flesh was crying out for her to rebel. I don't imagine it was easy when Abraham told her they were leaving their homeland, especially when she asked where they were going and Abraham's response was, "To wherever God shows us to go." But she still followed, and that was just one way she served as a helpmeet to her husband.

The Visionary

Sarah was a visionary. She had a vision for Abraham, her family, her life, and her marriage. God had given them a powerful promise, and that gave her the ability to see the end from the beginning, to see what God had in store. And that vision enabled her to stay, to keep supporting her husband, to encourage and uplift him, to be a voice of wisdom, and to keep believing that the promise would come to pass.

That vision also enabled Sarah to call Abraham lord, a title of honor and respect.

> For in this manner, in former times, the holy women who trusted in God also adorned themselves, being submissive to their own husbands, as Sarah obeyed Abraham, calling him lord, whose daughters you are if you do good and are not afraid with any terror.
>
> —1 Peter 3:5–6

Let's face it, Abraham messed up a lot. And yet Sarah still called him lord. She still honored him, despite his mistakes. Because of the vision she had for Abraham, she recognized

who he really was. She knew that God was at work, and she trusted God. The Bible speaks of calling things that are not as though they were (Rom. 4:17). In continuing to honor her husband by calling him lord, even when he wasn't acting worthy of that honor, Sarah was speaking words of life. She could see the end, so she kept declaring it. She kept speaking the vision over Abraham's life because she knew where God was calling him.

Modern-day Sarahs are also visionaries. They have been given the grace to see things from God's perspective. They too have a vision for their lives, their husbands, and their children, both natural and spiritual. And having that vision, that perspective, really is a grace. When the Holy Spirit gives you a vision of what the fulfillment of your promise will be, it gives you hope, it gives you stamina, and it helps you move forward. It also empowers you with the ability to have that meek and quiet spirit because you don't want to hinder the vision by cutting off your husband or anyone else at the knees with your words or actions. There are times when Sarahs will be quiet, not because they don't have anything to say, but because they have the maturity to know their words are powerful. They keep that power under control, knowing that they are keepers of the vision and they don't want to jeopardize it.

The Power of Submission

There is power in submission. The Greek word for submit is *hypotassō*. It means a voluntary attitude of cooperation, to

submit yourself, to yield, to obey, or to subject yourself to.[2] That means submission is a choice.

Sarah chose to submit to Abraham. It was easy to submit to him because he was following the Lord—the idea of submission mutual. Of course, given the time period and culture she lived in, it would have been nearly impossible for her to flat out refuse Abraham, but submission is about more than obeying. Submission is about your attitude when you obey. If you obey someone, but you whine and complain and grumble, you are not submitting. You can obey your husband in absolutely everything but make both your lives absolutely miserable by never submitting to him. Submission is about the heart behind your actions.

The Bible compares submission in marriage to the relationship between Christ and the church:

> Wives, submit to your own husbands, as to the Lord. For the husband is head of the wife, as also Christ is head of the church; and He is the Savior of the body. Therefore, just as the church is subject to Christ, so let the wives be to their own husbands in everything.
>
> Husbands, love your wives, just as Christ also loved the church and gave Himself for her, that He might sanctify and cleanse her with the washing of water by the word, that He might present her to Himself a glorious church, not having spot or wrinkle or any such thing, but that she should be holy and without blemish. So husbands ought to love their own wives as their own bodies; he who loves his wife loves himself. For no one ever hated

his own flesh, but nourishes and cherishes it, just as the Lord does the church.

—EPHESIANS 5:22–29

Submission done God's way means you don't have to worry about being vulnerable. When a wife submits to a husband who loves her the way Christ loves the church and is willing to lay down his life for her, the marriage is a safe place. When the husband and wife are both fulfilling their roles, they harness the power of agreement. When they submit to each other (don't overlook the verse right before the passage about husbands and wives: "submitting to one another in the fear of God" (Eph. 5:21), they can fulfill the will of God with grace and ease. They walk together in alignment. They have peace, prosperity, and productivity. They stay true to their covenant. They are fruitful. They have dominion. They get to see everyone's vision fulfilled.

And the truth is that biblical submission can really take a weight off you. When you are walking in godly submission to your husband, you don't have to be in the driver's seat all the time. By trusting and submitting to your husband, you are getting rid of a burden you were never meant to carry. It's a beautiful thing when you are able to support and lift up someone who is taking up the number one spot the way God has called him to. When you are both filling the role God has designed you for, it is powerful. When you submit to and prefer one another, it is easier to be creative and accomplish the purposes of God.

Submission is ultimately about submitting to God. The

Bible says that "there is no authority except from God, and the authorities that exist are appointed by God" (Rom. 13:1). So whenever you submit to your husband, your pastor, or any other authority figure, you are really submitting to God. But to be clear, you do not have to submit to anyone who is endangering you or your children or telling you to do something that is contrary to the Word of God.

> Sarah obeyed Abraham [following him and having regard for him as head of their house], calling him lord. And you have become her daughters if you do what is right without being frightened by any fear [that is, being respectful toward your husband but not giving in to intimidation, nor allowing yourself to be led into sin, nor to be harmed].
>
> —1 PETER 3:6, AMP

There are some who use the concept of submission to abuse or mistreat people, especially the oppressed, marginalized, or underprivileged. They will be held accountable for that because it misrepresents God's heart toward women. It was never God's intent for submission to be used as an excuse for abuse.

As a modern-day Sarah, you have been called to submission, whether to your earthly husband or, if you are single, your Maker, who is your husband (Isa. 54:5). Walking in submission helps keep you right in the middle of God's will, which is the best place to be.

Helpmeet Gone Bad

As I've said, helping is part of our nature as women. We were designed to be helpers. But sometimes that desire to help can lead to trouble. Think of Bonnie and Clyde. Some people wonder how Bonnie could ever participate in all those robberies with Clyde. I think it was her desire to help. It was a case of a helpmeet gone bad.

When we run into a case of a helpmeet gone bad, we often see that the man was not stepping up to fill his role. Eve was deceived by the serpent, ate the fruit, and then gave it to her husband, but Adam was standing there the whole time. He didn't lead. He didn't protect. He didn't speak the truth. The consequences were disastrous, not only for Adam and Eve but for the entire human race.

Jezebel was another case of helpmeet gone bad. She was married to King Ahab, who "did evil in the sight of the LORD, more than all who were before him" (1 Kings 16:30). But Ahab wasn't fulfilling his role, either as a king or a husband. He let Jezebel do his dirty work. He surrendered his authority to Jezebel, and because of that a man was killed, a vineyard was stolen, and calamity and death befell Ahab's family.

Women who step up to do things that a man was supposed to do are often labeled Jezebels. They are accused of usurping the man's authority and trying to take over because the man didn't step up. But it takes an Ahab for there to be a Jezebel. When men are doing their jobs, filling their roles, and doing the things God has called them to do, then

women can't do those things because they have already been done. There can't be Jezebels if there aren't any Ahabs.

Sarah herself landed in the category of helpmeet gone bad when she offered Hagar to Abraham instead of trusting God to fulfill His promise. So as a modern-day Sarah how do you avoid becoming a helpmeet gone bad? It starts with really trusting the Lord. Lean on God. Ask Him for discernment and wisdom so you know where the line is in your situation. In preparing to write this book I studied the words *meek* and *quiet*. In the Old Testament, the meek are those who wholly rely on God rather than their own strength to defend against injustice. Meekness is the opposite of self-assertiveness and self-interest. It stems from trust in God's goodness and control over the situation.

When you can't pay the rent, you need to recognize that there is a difference between a man who got laid off and has been pounding the pavement looking for a job for six months and a man who sits on the couch all day, watching television and eating potato chips. You also need to recognize that there is a difference between a man who is abusive and a man who is unsaved. Loyalty should never be to the point of self-endangerment.

Also recognize that you may be progressing at different levels in your growth process. That is another reason to ask God for wisdom, but don't be afraid to speak up and use your voice. Seek wise counsel. Use the Word of God as a measuring line. And don't forsake righteousness for the sake of being right. You don't want to get in the way of God's process.

Lord, Heal My Abraham

Abraham, the father of faith, was at times full of fear. Because of that fear, he sacrificed Sarah—he lied and asked her to lie, and he put her in a dangerous position. As a modern-day Sarah, when your Abraham is acting out of fear, you need to hit your knees, praying for God to heal him.

There have been times in my marriage when I've had conversations with God about my husband, and God has told me, "I've trusted you with him." I had a choice about whether to marry my husband, but once I said yes I was entrusted with him. God brought us together for a reason, and I need to take that trust seriously by praying for my husband.

The helpmeet is a praying wife. There is power in a praying wife. Your husband, or future husband if you are single, is still in a growth process, just as you are. He is still becoming the man God has called him to be. You are the visionary; being able to see your husband from God's perspective is your superpower. When the Holy Spirit gives you His perspective of your husband and His vision for your future together, you will find yourself praying for your husband even more and extending him grace in a different way.

Settle within yourself that you are the helpmeet. Your husband is not. Woman of God, you have been created and called to be a helper. It's time to fulfill that calling.

Prayer for the Helpmeet

Lord, let me be the helpmeet You have called me to be. I look to Your Holy Spirit as my example. Fill me with wisdom, understanding, grace, and truth. Help me to use my voice wisely and speak words of life to those around me to encourage, exhort, edify, comfort, and counsel. Give me Your vision and help me to keep it always in view. Give me eyes to see in others what You see in them. I choose to submit to You, and I choose to submit to my husband. I will not just obey, but I will obey with a good attitude. I will pray for my husband, and I will be a helper. Lord, give me the grace to be the woman of God You have called me to be. In Jesus' name I pray. Amen.

Chapter 5

THE NECESSITY OF HOPE

This hope we have as an anchor of the soul, both sure and steadfast.

—Hebrews 6:19

THE SARAH ANOINTING is about becoming a woman of belief, vision, and hope. Hope is critical to the anointing. It is a necessity for both belief and vision. Without hope, you can't have faith, because "faith is the substance of things hoped for, the evidence of things not seen" (Heb. 11:1). And when you lose hope, you lose the vision.

Hope is not just wishful thinking. It is so much more than that. Hope is the expectation to see the goodness of God in your life. Hope is the confidence that God will keep His promises.

> Then Abraham waited patiently, and he received what God had promised....God also bound himself with an oath, so that those who received the promise could be perfectly sure that he would never change his mind. So God has given both his promise and his oath. These two things are unchangeable because it is impossible for God to lie.

> Therefore, we who have fled to him for refuge can have great confidence as we hold to the hope that lies before us. This hope is a strong and trustworthy anchor for our souls.
>
> —HEBREWS 6:15, 17–19, NLT

Hope is an anchor for your soul, and it is rooted in the faithfulness of God. Hope is a reservoir of strength for your mind, will, and emotions. Hope gives you the ability to wait patiently until you receive the promise.

When Hope Is Lost

Abraham and Sarah received a promise from God before they even left their homeland. God told Abraham, "I will make you a great nation" (Gen. 12:2). Those few words contained the promise of a child for Abraham and Sarah. They waited, but the promise didn't come to pass.

The Lord appeared again to Abraham in a vision and specifically said, "One who will come from your own body shall be your heir" (Gen. 15:4). So they waited. And they waited. And they waited. Ten years passed from the time the Lord first appeared to Abraham, but the promise still didn't come to pass.

When you are in a season of barrenness, waiting for the promise of fruitfulness to be fulfilled, it can be hard to keep hoping, for "hope deferred makes the heart sick" (Prov. 13:12). Hope is what gets you out of bed in the morning, but hopelessness can create a place of desperation. I think Sarah was approaching that place of desperation at the ten-year mark.

For ten years she faced disappointment over and over again, every single month, when God's promise did not come to pass. And that was just the ten years after the promise. Before the promise, Sarah and Abraham faced the same disappointment in their failure to conceive for decades. Having a son, an heir—someone to pass on the family legacy to—was so important, but it never happened.

I believe Sarah had reached that point of desperation. I wonder if she decided to just do what she knew to do—offer her maidservant as a surrogate. It was a common enough practice in those times. I also wonder if she secretly hoped that when she offered Hagar as a surrogate, Abraham would push back and say, "No way! I'm waiting for the promise to be fulfilled through you." Sarah and Abraham had been walking together for probably fifty or sixty years at this point, so even though the use of a surrogate was the custom, I think it still was really painful for Sarah when Abraham called her bluff, so to speak, and agreed to the idea.

The problem with acting out of desperation is that it produces Ishmaels. When we try to fulfill God's plan in our own strength, putting a plan together to "help" God out, it produces a child of the flesh rather than a child of the promise. That is why keeping the vision is so important; it helps you to know that God is going to bring you through, so you don't have to settle for the counterfeit of the promise.

Before Hagar got pregnant, Abraham and Sarah didn't really know who was to blame for their inability to have a baby. But when Hagar got pregnant, they knew. The problem was with Sarah.

Women who struggle with infertility often have a poor body image. They wonder, Why isn't my body doing what it is supposed to do? They may deal with self-hatred, self-condemnation, and self-loathing. But those feelings are not of God. You are fearfully and wonderfully made. You are enough, just as you are, because God has made you enough. Sarah understood those things. Even though there were points in her journey that were difficult, she never considered herself to be any less of a woman. She knew the truth about herself, and as one of her daughters you have inherited a legacy of believing the truth about yourself too. Coming to terms with the feelings and emotions connected with infertility may require some wrestling with God, but it is all part of your growth process, your process of transformation, as you develop faith for yourself.

If you are struggling with infertility, there is nothing wrong with seeking medical help. I think the medical profession is God's mercy gift to humanity. You are not less of a woman if you have to use medicine to help you have a baby. You are also not less of a woman if you choose adoption, especially since adoption is a beautiful picture of the way the family of God operates. You are enough because God has made you enough.

Hope Restored

Sarah and Abraham realized they got it wrong. I think Sarah may have realized her mistake early on, either when Abraham called her bluff about using Hagar as a surrogate

or when Hagar began to despise her after she got pregnant. Sarah and Abraham both knew for sure they had gotten it wrong when God appeared to Abraham again, this time thirteen years after Ishmael's birth.

This is the moment when God removed any and all doubt about who the child of promise would be. This is when Abraham's name was changed. This is also when Sarah's name was changed and God called her future into her present by calling her "a mother of nations" (Gen. 17:16). And then God laid it all out: "Sarah your wife shall bear you a son, and you shall call his name Isaac; I will establish My covenant with him for an everlasting covenant, and with his descendants after him" (v. 19).

This was the moment of realignment, the moment when they realized God's way was the right way and only through Him could His promises be fulfilled. When you realize you have gotten off track, taken the wrong path, or gotten in the way of what God is doing to fulfill His promises, you have to get realigned—with the promise, with the vision, and with God. You need to grab hold of your hope once again and hold fast to it, knowing that God is faithful.

> Let us draw near with a true heart in full assurance of faith, having our hearts sprinkled from an evil conscience and our bodies washed with pure water. Let us hold fast the confession of our hope without wavering, for He who promised is faithful.
>
> —Hebrews 10:22–23

The Lord is not slack concerning His promise.

—2 PETER 3:9

The Lord appeared again to Abraham by some trees near his tent, and He reiterated His promise: "I will certainly return to you according to the time of life, and behold, Sarah your wife shall have a son" (Gen. 18:10). Sarah was within earshot and heard the whole thing. The Bible says, "Sarah laughed within herself, saying, 'After I have grown old, shall I have pleasure, my lord being old also?'" (v. 12).

Sarah gets a lot of criticism for that laughter (although some people seem to overlook that Abraham laughed first and even fell on his face while doing so). People assume she laughed out of disbelief and doubt, and that is likely the case. But I wonder if it could have been something else. Given that Abraham and Sarah were "well advanced in age" (v. 11) and may not have had a lot going on in the bedroom, Sarah could have been laughing over the thought of the pleasure connected with making a baby. But what I really wonder is if finally hearing the promise for herself could have made joy bubble up inside her, as if she were given an impartation of the joy of the Lord. Hebrews 11:11 says Sarah "received strength" to conceive, and Nehemiah 8:10 says that "the joy of the LORD is your strength." I wonder if the moment Sarah laughed is the moment she received strength.

When it really comes down to it, hope restores laughter, restores joy, and we are living through times when we need to see joy restored. When Isaac was born, when the promise was fulfilled, Sarah said, "God has made me laugh, and all

who hear will laugh with me" (Gen. 21:6). Sarah had been on a roller-coaster ride of hope and disappointment, ups and downs and twists and turns, but her hopes were finally fulfilled with the birth of the child of promise. It's no wonder she had a heart full of joy and laughter.

> Listen to me, all who hope for deliverance—all who seek the LORD! Consider the rock from which you were cut, the quarry from which you were mined. Yes, think about Abraham, your ancestor, and Sarah, who gave birth to your nation. Abraham was only one man when I called him. But when I blessed him, he became a great nation.
>
> —ISAIAH 51:1–2, NLT

Waiting With Hope

When you really have hope, it helps you wait. After receiving the promise, you need endurance to hold on to hope. You need to keep the vision in view and keep going back to it. That is why God said to write the vision down (Hab. 2:2). And the great thing about God is you can keep coming back to Him, asking Him the same questions. He'll keep telling you over and over; He will keep confirming the promise. He will lovingly reassure you. Sometimes we think God is upset with us or weary of us coming to Him, but He's not like that. He's never impatient. He loves you. "The LORD is merciful and gracious, slow to anger, and abounding in mercy" (Ps. 103:8). When you understand how much God loves you, you can

have hope; you can have the confident expectation that you will see the goodness of the Lord in your situation.

When you have hope, instead of time being your enemy, it becomes your friend. You begin to see that God must still be working in you, that you are still in the process of growing and transforming into the woman God has called you to be. And the fact that God is still working in you can strengthen your hope, knowing that He isn't finished with you yet and His plans are still at work in your life.

As a daughter of Sarah, you can look to Sarah as an example of how the times of the Lord can play out in your life. One of the Greek words used in the Bible for *time* is *chronos*. It refers to general seasons of time or the chronological passage of time. *Chronos* includes the everyday, normal, mundane, routine stuff of life.

Another Greek word for *time* is *kairos*. Kairos times are life-altering moments within *chronos* time that launch you straight toward your destiny. It means the set time for something to occur, the "decisive epoch waited for."[1]

In the Book of Genesis, God told Abraham, "Is anything too hard for the LORD? At the appointed time I will return to you, according to the time of life, and Sarah shall have a son" (18:14). Just as there are two different Greek words for *time*, there are also two different Hebrew words used for *time* in this verse. The word used for *time* in the phrase *time of life* is *ēt*. It is the general term for time, referring to everyday occurrences and experiences.[2] It is comparable to *chronos* time.

The phrase *appointed time* is the word *mô'ēd*. It means appointment, a fixed time for a specific purpose. It is also

the word used for the tent of meeting, the place where the Israelites met with the Lord.[3] It is comparable to kairos time, those divine appointments when the Lord puts things supernaturally into place. When the apostle Paul wrote about God's promise to Abraham and Sarah, he said, "For this is the word of promise: 'At this time I will come and Sarah shall have a son'" (Rom. 9:9). The word for *time* in that verse is *kairos*.

So with Sarah, natural, chronological time converged with the miraculous appointed time. There were things that had to occur within Sarah's body over the course of natural time for her to be able to conceive and carry a child. Sarah was past the normal time of life for childbearing, but her body still had to go through the natural processes of that time of life to prepare her for her kairos moment.

The same thing happens with us as daughters of Sarah. If your promise is a natural child, there is a natural process your body has to go through during that time of your life to prepare you for your kairos moment. If your promise is a spiritual child or spiritual children, there is still a natural process you have to go through during that time of your life to prepare you for your kairos moment.

Waiting has everything to do with time, patience, and being able to discern the times. But waiting is not an idle process. During the waiting time, you are continuing your growth process and serving the Lord. The Bible says that those who wait on the Lord will renew their strength:

> But those who wait on the Lord shall renew their strength; they shall mount up with wings like

eagles, they shall run and not be weary, they shall
walk and not faint.

—ISAIAH 40:31

The word translated "wait" means to bind together, like
twisting strands of a rope together.[4] The waiting time is a
time for you to be bound together with the Lord so you get
stronger, so you are prepared to receive His supernatural
strength when your kairos moment arrives. You tie your
heart to His purpose and let Him bind you to His perfect
will, His vision for your life.

Waiting on God means waiting on the *chronos* time and
the kairos time to come together. Those two different times
have to intersect at the right time. And when they do, it
becomes the fullness of time.

The Fullness of Time

The fullness of time is the intersection of the natural (the
time of life, *chronos*) and the spiritual (the appointed time,
the opportune time, kairos). The phrase *fullness of time* is
used in connection with the birth of Jesus and the redemp-
tion of mankind (Gal. 4:4; Eph. 1:10). It is connected to
God's will, His purpose, His plans, and becoming part of
the family of God.

The Greek word for *fullness* is *plērōma*. It means com-
pletion, fullness, filled up.[5] It comes from a root word that
means to fill to the brim, to make complete in every detail,
to carry something through to the very end, to cause God's
promises to be fulfilled.[6] That intersection of *chronos* and

kairos is where the fullness happens, the place where God's promises are fulfilled in your life.

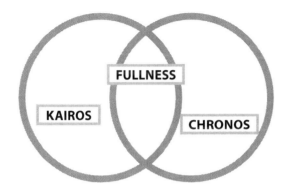

So after all the waiting, all the growing, all the hope and faith and love and prayers and tears and everything else that was a part of your process, in the fullness of time, Isaac comes. The manifestation of the promise arrives.

Daughter of Sarah, don't lose hope during your waiting time. God is at work in you, preparing you to receive the promise. God keeps His promises. You can count on that. So keep the vision. Let the joy of the Lord be your strength. And hold fast to your hope; it is the anchor of your soul.

Prayer for Hope

Lord, I put my hope in You. I expect to see Your goodness in my life. I am confident that You will keep Your promises. My hope in You is the anchor for my soul, so I will wait patiently until I receive the promise. I will not act out of desperation and try to do things in my own strength. Thank You that

I am enough, just the way I am, because You have made me enough.

Lord, if I have gotten off track, help me to realign with the promise, with the vision, and with You. Help me to grab on to my hope and hold it fast until the time when my promise is fulfilled, knowing that You are faithful. Give me a supernatural impartation of Your joy, because the joy of the Lord is my strength. Restore joy to me and my generation and to all the generations that come after us.

Lord, help me to stay bound together with You during my waiting time. I choose to wait until chronos time and kairos time intersect in the fullness of time. And as I wait on You, You will renew my strength. Thank You, Lord Jesus, for being my living hope. In Jesus' name, amen.

Chapter 6

CASTING OUT THE BONDWOMAN

Nevertheless what does the Scripture say? "Cast out the bondwoman and her son, for the son of the bondwoman shall not be heir with the son of the freewoman."

—GALATIANS 4:30

ONCE YOU RECEIVE the manifestation of your promise, you have to nurture the promise. In order to nurture the promise, you have to cast out the bondwoman. It is part of the proper management of your promise. The child of flesh and the child of promise cannot grow to maturity together.

Ishmael and Isaac grew up together until the time Isaac was weaned, probably when Isaac was three or four years old. Ishmael would have been about seventeen or eighteen at the time. Sarah had watched Ishmael grow up, and she recognized that because Ishmael was older, Isaac would look to him as a leader. Isaac would never step into his destiny with Ishmael around.

At the time when Isaac was weaned, Ishmael, the child of the flesh, was scoffing at Isaac, disrespecting him. It deeply offended Sarah.

> And Sarah saw the son of Hagar the Egyptian,
> whom she had borne to Abraham, scoffing.
>
> —GENESIS 21:9

The Hebrew word for *scoffing*, in addition to meaning mocking, jesting, laughing in scorn, or making sport of, can also mean laughing in merriment or playing.[1] But Paul's letter to the Galatians makes it clear that Ishmael was not playing:

> But, as he who was born according to the flesh then persecuted him who was born according to the Spirit, even so it is now.
>
> —GALATIANS 4:29

The Greek word for *persecuted* means to make flee, put to flight, persecute, mistreat, harass, pursue in a hostile manner, or molest.[2] This was not play. This was not even good-natured teasing. Ishmael was bullying and persecuting Isaac.

Ishmael's character was foretold by the angel of the Lord when He spoke to Hagar:

> He shall be a wild man; his hand shall be against every man, and every man's hand against him.
>
> —GENESIS 16:12

Maya Angelou said, "When someone shows you who they are, believe them the first time."[3] Ishmael was showing who he was by scoffing, and Sarah believed him. Because of Ishmael's behavior, Sarah went to Abraham and said, "Cast out this bondwoman and her son; for the son of this bondwoman

shall not be heir with my son, namely with Isaac" (Gen. 21:10). This was not the first time Sarah had gone to Abraham about Hagar. When Hagar got pregnant with Ishmael, "her mistress became despised in her eyes" (Gen. 16:4).

> Then Sarai said to Abram, "My wrong be upon you! I gave my maid into your embrace; and when she saw that she had conceived, I became despised in her eyes. The LORD judge between you and me."
>
> So Abram said to Sarai, "Indeed your maid is in your hand; do to her as you please." And when Sarai dealt harshly with her, she fled from her presence.
>
> —GENESIS 16:5–6

Abraham was not walking in his authority. He was not covering his wife. And Sarah recognized that the deeper issue was not about Hagar. It was about her and Abraham. I believe Sarah had good intentions when she suggested Hagar as a surrogate and was trying to move toward the promise, but she was deceived. I think she recognized that. But Abraham was the one God had spoken to directly. When she said, "The LORD judge between you and me," it was as if she was saying, "God knows my heart in this situation. What about yours? I messed up, but what are you going to do about it? You're my husband, and you're supposed to cover me." But Abraham threw it back on Sarah, telling her to do whatever she wanted.

When Sarah went to Abraham again, he was still apparently in a growing process since his initial reaction was displeasure. But the Lord stepped in:

> Do not let it be displeasing in your sight because of
> the lad or because of your bondwoman. Whatever
> Sarah has said to you, listen to her voice; for in
> Isaac your seed shall be called. Yet I will also make
> a nation of the son of the bondwoman, because he
> is your seed.
>
> —GENESIS 21:12–13

Abraham listened to the Lord and listened to his wife, and he sent Hagar and Ishmael away.

Flesh Versus Spirit

The difference between Sarah and Hagar, between Isaac and Ishmael, is the difference between the Spirit and the flesh. While at the time Sarah and Abraham lived using a surrogate was common, it still wasn't what God wanted. It is even possible that Abraham married Hagar, as Genesis 16:3 says Sarah gave Hagar "to her husband Abram to be his wife." Polygamy was also common at the time, but it still wasn't what God wanted. From the very beginning of creation, God intended marriage to be between one man and one woman (Gen. 2:24).

Just because cultural rules and man-made traditions say something is OK doesn't mean that it is. Just because something is common does not mean it is godly. That is why we need to walk in the Spirit and allow the Lord to guide us as we pursue His purposes in our lives.

The difference between the flesh and the Spirit is the

difference between bondage and freedom. When you are walking in the flesh, you are bound by the works of the flesh:

> Now the works of the flesh are evident, which are: adultery, fornication, uncleanness, lewdness, idolatry, sorcery, hatred, contentions, jealousies, outbursts of wrath, selfish ambitions, dissensions, heresies, envy, murders, drunkenness, revelries, and the like; of which I tell you beforehand, just as I also told you in time past, that those who practice such things will not inherit the kingdom of God.
>
> —GALATIANS 5:19–21

These things are in direct opposition to the fruit of the Spirit:

> But the fruit of the Spirit is love, joy, peace, long-suffering, kindness, goodness, faithfulness, gentleness, self-control. Against such there is no law. And those who are Christ's have crucified the flesh with its passions and desires. If we live in the Spirit, let us also walk in the Spirit.
>
> —GALATIANS 5:22–25

As a daughter of Sarah, it is important that you walk in the Spirit and not in the flesh. When Sarah came up with the idea of using Hagar as a surrogate, she was walking in the flesh. God had divinely planned and orchestrated everything, but she took it out of His hands and brought in all kinds of other things: adultery, fornication, idolatry, hatred, contentions, jealousies, outbursts of wrath, dissensions, selfish ambitions, and envy—quite a large number of things

from Paul's list of the works of the flesh. And that is how sin works. It's almost as if one sin gives birth to another, which gives birth to another, and so on.

Casting Out

The casting out of the bondwoman is a deliberate act of cutting off and letting go. You have to recognize that there is a problem getting in the way of the promise, and you have to make the decision to deal with it. You have to come to a place of resolve, no more wavering back and forth. And then you have to execute your decision.

Daughter of Sarah, a large part of casting out the bondwoman is renewing your mind. You need to fall out of agreement with the works of the flesh, put the right perspective in place, and maybe even get some deliverance. You need to confront your mistake, acknowledge your wrong, ask for forgiveness, forgive yourself, and then cut it off.

Casting out the flesh is like taking the whole thing that led you down the wrong path; putting it in a nice, neat bundle; and sending it on its way. Hagar is a symbol of the flesh, and while you can't physically cast out your flesh, you can cast it out in a spiritual sense—you can crucify it. In fact, that is what the apostle Paul said to do when he was contrasting the works of the flesh and the fruit of the Spirit: "And those who are Christ's have crucified the flesh with its passions and desires" (Gal. 5:24). You have to renew your mind and let it be transformed by the Word of God. All those parts of your

character that developed according to the works of the flesh need to be replaced by the fruit of the Spirit.

Once you have made your decision to cast out the bondwoman and you take steps to see that happen, God will back up your decision. When Sarah went to Abraham, Abraham was displeased, but God backed her up and told Abraham she was right. As a daughter of Sarah, you may or may not have an earthly Abraham to walk with you through this process, but even if you don't, it doesn't negate your personal responsibility to separate yourself, disengage, or move whatever it is out of your life. Just as Sarah turned to Abraham for help, you can turn to God to help you.

God's confirmation or affirmation of your decision can come in a number of ways. He may speak directly to your Abraham, just as He did for Sarah. He may also speak through a counselor or through His Word. God loves His girls, and He will always come through for you, especially when it is hard to do the right thing.

The decision to cast out is a spiritual one, but there also needs to be a natural execution. You need to take action to get rid of the works of the flesh in your life. If you are involved in adultery or fornication, the relationship needs to end.

Moving Forward

Once you have cast out the bondwoman, it's time to move forward. That's what Sarah did. As a daughter of Sarah, you can't be afraid to rock the boat. God has given you a vision, and if you have gotten off track, you need to take

the necessary steps to get back on track. If you have been walking in the flesh, you need to start walking in the Spirit.

Acknowledging your mistakes is an important step, but don't let your mistakes keep you stuck. Be confident and humble enough to admit your mistakes, but don't let anyone pigeonhole you with them. You are not defined by your mistakes. You are a child of grace. If you have confessed your sins and asked God to forgive you, He has removed your sins as far away as the east is from the west.

> As far as the east is from the west, so far has He removed our transgressions from us.
>
> —PSALM 103:12

So once you have been forgiven, accept that forgiveness and move forward. Don't be controlled or manipulated by guilt over sins God doesn't even remember anymore.

> For I will forgive their iniquity, and their sin I will remember no more.
>
> —JEREMIAH 31:34

Yes, there are times when we have to live with the consequences of our decisions, but that does not mean you stay bound up in guilt and shame. God's mercies are new every morning.

> Through the LORD's mercies we are not consumed, because His compassions fail not. They are new every morning; great is Your faithfulness.
>
> —LAMENTATIONS 3:22–23

You don't need to stay in a state of wearing religious sackcloth and ashes. Don't put on some kind of religious mask, saying you are OK when you are not. That is bondage. But you are not a bondwoman. As Paul wrote, "We are not children of the bondwoman but of the free" (Gal. 4:31). You are not a daughter of Hagar; you are a daughter of Sarah. You are free! If the Son has set you free, you are free indeed (John 8:36). So "stand fast therefore in the liberty by which Christ has made us free, and do not be entangled again with a yoke of bondage" (Gal. 5:1). Face your mistakes, fall out of agreement with them, learn from them, and keep moving.

Lessons From the Bondwoman

Even though Hagar was the bondwoman who needed to be cast out, there are still some lessons that the daughters of Sarah can learn from her.

Don't spend too long serving someone else's vision.

We need to be in tune with God's timing about when to stay and when to go when serving someone else's vision. When Hagar first ran away, the Lord appeared to her and told her to go back and submit to Sarah. He also promised that He would multiply her descendants exceedingly. So Hagar went back. But the time came when it was really time for her to go, and God confirmed that by appearing to her once again, providing for her and Ishmael, and reiterating His promise that Ishmael would also become a great nation. Her time serving the vision God had given Abraham and Sarah was over.

You may be in a similar situation where you are serving someone else's vision. You need to be seeking the Lord about the fulfillment of the vision He has given you. Serving someone else's vision may be a part of your growth process, but don't fight it when God moves you on. Sometimes we overcommit and self-sacrifice in a way God never commanded us to do. At the end of the day, you need to understand your identity, have appropriate boundaries, and pursue the vision God has given you.

God won't bless the mess.

When Hagar got pregnant, she began to despise Sarah. It's as if she believed she was going to take Sarah's place. But that was not God's plan. Abraham's marriage covenant was with Sarah, and God's covenant promises were going to be fulfilled through their covenant.

Don't ever deceive yourself into thinking you are going to take the place of a man's wife. You are not the covenant woman. No matter how many children you have by him, chances are he will never leave his wife for you. If you are currently involved in an affair, you need to understand that God will not bless your mess. Whether one or both of you involved in the affair is married, a covenant is being broken, and God is always concerned about covenants. And even if you are both single, you are still in error because God designed sex for within the bounds of a covenant marriage. God is not going to bless that, and you are opening up the door to destruction. But there is a place of redemption if you turn and repent.

God will take care of you.

Hagar was not the one chosen to bear the child of promise. She was not Abraham's first wife. She was not part of God's plan for His covenant with Abraham. But God still took care of her. Both when she ran away and when she was cast out, God intervened to provide for and protect her.

Single women, and single mothers in particular, come under a lot of attack, and they face many challenges. But you can trust God. He will take care of you. He will provide for and protect you. You may have gotten off track and lost sight of your purpose, but God still loves you.

You are a daughter of Sarah. You are a woman of belief, vision, and hope. It's time to walk in the Spirit, not in the flesh.

Prayer for Casting Out the Bondwoman

Lord, You have given me a promise, and I choose to nurture that promise. I choose to cast out the bondwoman. I will not walk in the flesh or be bound by the works of the flesh. I will walk in the Spirit, and my life will demonstrate the fruit of the Spirit.

Lord, I fall out of agreement with the works of the flesh, and I confess my sins to You. Lord, forgive me, restore me to a right relationship with You, and then help me to forgive myself so I can move forward. I choose to crucify my flesh and renew my mind so that I can be transformed. Thank You that Your mercies are new every morning. Thank You for Your faithfulness. Thank You that I am free. Help me to stand fast in the freedom You died to give me. I love You, Lord. In Jesus' name I pray. Amen.

VISION FOR YOUR UNION

Can two walk together, unless they are agreed?

—Amos 3:3

SARAH AND ABRAHAM were a power couple. They were called to be something great together. They were called to change the world together. But being a power couple and changing the world takes a lot of work. It also takes a lot of humility.

All couples that God calls to do things together to advance the kingdom have at least a degree of the dynamic between Sarah and Abraham in their relationship. Every union between a husband and wife has a kingdom purpose. It may be to start a church or a ministry or a business, or it may be to just work regular jobs and love their kids well. But each couple has a purpose. Once you have a vision for your union and you know why you are together, you can set goals and see them achieved to make the name of Jesus famous in the earth. And as a couple you can produce sons and daughters, whether natural or spiritual or both, all to grow the kingdom of God.

Just because your relationship with your Abraham isn't

perfect doesn't mean he's the wrong person. There may be some slips and falls. There may be times when he is not being all that he is supposed to be and fulfilling the role God designed for him. But that is part of his growth process, his renewal process. It doesn't mean he is the wrong person. It just means that God is still working in him, just as He is in you.

Called Out

Abraham and Sarah went through a process together. They didn't get married and instantly become the father and mother of faith and have God make a covenant with them. There was a progression, a path they had to follow. And the beauty of it all is that they followed it together.

It started when they were called out. They were called out of their country, away from their family, and out of Abraham's father's house. They were called completely out of their culture because God was going to do something new. He was going to use them to create a new culture.

If God is calling you and your Abraham out of something, you need to heed that call. There are times when God wants to put separation between us and the things that may distract us, slow us down, or even block us from pursuing the vision He has given us. Sometimes He calls us out so the voices we have spent our lives listening to don't drown out His voice. When there is a voice behind you saying, "This is the way, walk in it" (Isa. 30:21), you don't want to miss that voice because of all the others shouting in your ears.

God didn't just call Abraham and Sarah out of something. He called them into something.

It's interesting that when God changed Abraham's and Sarah's names, the Hebrew H sound was inserted. The letter, among other things, stands for breath. The letter also occurs twice in God's name, YHWH, and is even the letter used as an abbreviation for *Hashem*, the word used in Judaism to refer to God to avoid the possibility of taking God's name in vain. When God renamed Abram and Sarai, He put His name into both of theirs.[1] He was giving them His breath, the supernatural breath of the Almighty, giving life to a couple who were "as good as dead" (Heb. 11:12) so that through them generation after generation could be blessed.

By renaming both Sarai and Abram, God was calling them into something more. He called them into walking together with Him. He called them together into blessing. He called them together into covenant. God is calling you into the same things: into walking together with Him, into blessing, and into covenant.

But for Abraham and Sarah to walk together toward all that God had called them into, they had to be in agreement.

> Can two walk together, unless they are agreed?
> —Amos 3:3

Every marriage has a purpose, and it is different for everyone, but the husband and wife need to be in agreement about that purpose. Especially when God is calling you out and you don't know where you are going—as was the case with Abraham and Sarah—being in agreement, both of you

having a yes in your hearts, is vital. For when you have that yes, it gives you the grace to handle all the unknowns as you walk your God-given path together.

When you have the vision for your union, when you know your purpose, and when you are both in agreement, you can both be comfortable with your defined roles. That agreement means you can do what you are called to do and be OK with it, whether you are on the front lines or not. One of you may be the CEO while the other handles humanitarian efforts. You may be together in a ministry where both of you have a strong voice, or one of you may have a strong voice while the other is in a supporting role. One of you may be in ministry while the other is a businessperson. One of you may be working a regular job while the other one homeschools your seven children. The roles don't have to be traditional, but they can be. The vision for your marriage should allow both of you to use the gifts God has given you in your respective roles so you can find that place of synergy and unity.

The Power of Difference

When God created Adam and Eve, He created them to be different. Men and women are different from each other. Our bodies are different, and we can have different gifts and different strengths and weaknesses. God did not create women to do everything men can do, nor did God create men to do everything women can do. But that does not mean that women are somehow inferior to men or that men are somehow inferior to women. God made us different, and we need to embrace

that difference rather than try to eliminate it or pretend it doesn't exist. Satan is the author of division, confusion, and strife between women and men. God wants us to move and work together, but Satan does everything in his power to get in the way of that, for even Satan recognizes that we are better together and that our differences make us stronger.

Men and women are equals, but that equality does not mean they are the same. Rather, it means each individual is valued and honored for his or her unique contribution. The male and female natures are both a reflection of something unique and powerful in the character of God. We should celebrate those differences, not ignore them. It is OK for women to be feminine. Godly femininity is a blessing to homes, to workplaces, to churches, and to the kingdom of God. God has given women unique gifts to impart blessing to the nations of the world for generations to come. We are sensitive and therefore more prophetic and intuitive. We are nurturers. We are helpers. We champion dreams and visions. We are the daughters of Sarah, and we will do good and not be afraid, using the very gifts God gave us that make us different.

Differences are important. God doesn't create covenants based on sameness. Covenants bring people together so they can benefit from each other's strengths. If everyone had the same strengths, the covenant would not have much of a purpose. When a man and a woman enter into a marriage covenant, the idea is for their strengths and weaknesses to complement and cover each other. The Word says that "love will cover a multitude of sins" (1 Pet. 4:8). One person's

strengths can be the answer to the other person's weaknesses, and vice versa. Celebrating and valuing your differences will help you both move forward in your growth process. The very differences you have are behind your superpower as a couple, and they will become your greatest strengths when you acknowledge them, honor them, and use them effectively in pursuit of your purpose.

Women need to be recognized for their unique strength and unique value. They need to be empowered to be feminine and to use their unique gifts. Let me be clear: I am not talking about some awakening of a selfish, live-your-truth, bra-burning feminist movement that wants complete independence from men and sacrifices family life on the altar of doing me. The feminist movement didn't start that way. It was about allowing women to have freedom and equal rights and opportunities, not about hating men. This is about valuing women exactly as God made them.

Sarah recognized her value as a woman. She had different strengths than Abraham did, and her strengths helped to cover some of his weaknesses. For example, Sarah was a contender for the vision God had given them. When Abraham was getting off track, she used her voice to try to get back onto the right path. As a modern-day Sarah, you also need to recognize your value as a woman. God did not make a mistake when He designed you the way He did. You are fearfully and wonderfully made. The things that make you uniquely you are gifts; they are blessings.

While Sarah recognized her own value, she also recognized the value of Abraham. His gifts were different, and

she looked to him to cover her and protect her by using those gifts. Modern-day Sarahs must do the same. They must recognize the value of the men in their lives, especially their Abrahams, and honor and respect those gifts. Yes, we are different, but there is power in that difference. And when we, as daughters of Sarah, both married and single, begin to demonstrate valuing and celebrating the differences between us and the men in our lives, the next generation will take notice. Honoring each other's differences will become part of the spiritual legacy we leave for the generations to come.

Walking With Your Abraham

As you are walking with your Abraham, he will have stages in his growth process. At first Abraham was selfish, fearful, and insecure, and he didn't know where he was going. He was all of those things, but Sarah still called him lord. She had a vision for their union, so she was able to see what God was doing in her husband.

Abraham was given a vision too, but it seems as if Sarah had an awakening about it before Abraham did. So when Abraham was getting off track, Sarah had to keep reminding him. And even though both Abraham and Sarah had the vision, I think they both had an incorrect interpretation of it at one point. You can have the heavenly vision, but an incorrect interpretation means you may apply it incorrectly, which could lead to an incorrect manifestation. That is what was happening when Abraham and Sarah decided to use a surrogate.

An incorrect interpretation is like a roadblock on the path toward your purpose. Other roadblocks can include prejudices, rejection and fear of rejection, bitterness, and being judgmental. Developing the discipline of self-examination can help you and your Abraham overcome these and any other roadblocks. Even if you are single and still waiting on your Abraham, self-examination is a discipline that can help prepare you for when God sends your Abraham to you. Praying Psalm 51 over your life is a good place to start. Then use these four steps to help address any hidden issues of the heart and overcome any roadblocks:[2]

1. **Desire truth in your inward parts.** The first step to overcoming these stumbling blocks is having a desire for truth in the inward parts. We should desire truth that is not superficial, but truth that reaches far deeper than a mere intellectual comprehension of truth; it is truth that reaches down into the depth of our being. The opposite of the truth is deception. The worst kind of deception is self-deception. The power of deception is that the person being deceived believes he or she is being led of the Lord. It takes the mercy and power of the Holy Spirit to break through deception.

2. **Allow the Holy Spirit to search your heart.** The second step to overcoming roadblocks is to allow the Holy Spirit to search your heart, shining a light on any wicked area. The Holy Spirit is the Spirit of truth. He will give you wisdom in the

hidden areas of your heart. Psalm 139:23–24 says, "Search me [thoroughly], O God, and know my heart! Try me and know my thoughts! And see if there is any wicked or hurtful way in me, and lead me in the way everlasting" (AMPC). Once the Holy Spirit searches your heart and reveals blocks and flaws, you must be honest with yourself and not try to justify your actions. David states in Psalm 51:3 that he acknowledged his sin and transgression. Recognizing sin and error requires humility and brokenness. It's also the first step to healing and deliverance.

3. **Repent immediately.** The third step to overcoming roadblocks is to repent immediately. Once the Holy Spirit convicts you of a roadblock, there is an anointing in that moment to be healed, delivered, and transformed. Delayed response can lead to hardness of heart and greater deception. The word *repent* comes from the Greek word *metanoia*. In this compound word "the preposition combines the two meanings of time and change, which may be denoted by 'after' and 'different'; so that the whole compound means: 'to think differently after.' Metanoia is therefore primarily an afterthought, different from the former thought; a change of mind accompanied by regret and change of conduct, '[a] change of mind and heart,' or 'a change of consciousness.'"[3] Based on this definition, repentance means after the

Holy Spirit has revealed information, you change your way of thinking. The wrong road will never become the right road. The only way to get on the right road is to discover where you made a detour and turn around immediately.

4. **Rend your heart.** The fourth step to overcoming roadblocks is to rend the heart. In Joel's day people tore their garments to show their grief and desperation. However, what God desires is the tearing of our hearts, which speaks of dealing radically with the matters of our heart. To rend means to tear something violently or forcibly. We tear our heart away from everything in our lives that quenches or blocks the pure flow of the Spirit! Tearing our heart is intensely personal and painful. Some want the Spirit to free them from their sinful patterns without it requiring any personal choices that tear their heart. That is not the way it happens.

> And rend your heart, and not your garments, and turn unto the LORD your God: for he is gracious and merciful, slow to anger, and of great kindness, and repenteth him of the evil.
>
> —JOEL 2:13, KJV

Another important aspect of the renewal process as you are walking together with your Abraham is to break demonic covenants. When Abraham got Sarah to agree to say she was his sister instead of his wife, it was a demonic covenant that

opened them up to all types of unnecessary attacks. They made an unholy, ungodly alliance, and God had to intervene to get them out of it. While it is true that God worked it all out for their good, they never should have made a vow that was potentially detrimental to their marriage in the first place. Sarah could have had to sleep with another man. She could have been killed. They should have trusted God.

Later on, when Sarah and Abraham decided to use Hagar as a surrogate, it was another example of a time they should have trusted God instead of agreeing to do things their own way. Yes, they were supposed to have a son. They were right about that. But Hagar was the wrong woman. They were trying to fulfill the promise outside of the covenant.

If you and your Abraham have made any kind of demonic vows or covenants, you need to identify them and renounce them, even if they were made in ignorance. It is part of the renewal and growth process, just like casting out the bond-woman. You need to acknowledge that you were wrong, you made a mistake, and you can't operate like that anymore. As believers, you have been called to righteousness. You have been called to walk in the Spirit, not in the flesh. God wants you to be fully representing kingdom principles. As a couple, you need to fall out of agreement and renounce anything that has hindered you from going the right way and from walking in the purpose of God for your marriage.

God wants you to walk in the fullness of what He has for you. Sometimes you can get fooled into thinking you have the anointing of God or God's favor because you are flourishing, but that may not necessarily be the case. If you don't

have the peace of God, you are not where God wants you to be. God is very strategic. He knows the end from the beginning. So don't be deceived—you need to do it His way. You need to walk in righteousness with your Abraham.

Praying for Your Abraham

Praying for your Abraham is part of the Sarah anointing. Your prayers are powerful, and when women pray for their husbands, it has a tremendous effect on both their husbands and the women themselves. When you find the one you are supposed to be walking with, you see things that God will never allow other people to see. That allows you to pray all the more effectively for your husband. And even if your Abraham has yet to arrive, you can still be praying for him. Your effective, fervent prayers for your future husband will avail much.

Pray for your husband's deliverance. Pray that he will be delivered from his fears. I believe Abraham was fearful more than anything else. Pray for him to be delivered from anything that will stop him from fulfilling his destiny.

Pray for his healing, his self-image, his finances, his vision, his work, his mind, his protection, his integrity, and his faith. Pray for every part of him. And pray for his marriage and for yourself, his wife. The two of you together make a power couple, but you need to be walking *together* in faith, love, hope, unity, and humility.

Prayer for Your Abraham

Father, I thank You for my husband. I ask that You will cause his dreams and godly desires to come to pass. Lord, I ask that You will protect our marriage covenant from anything or anyone that would come to destroy it. I pray that my husband would see himself as You see him. Give him the ability to walk by faith and not by sight. Let him believe You and Your words and walk in Your power. Make him a wise master builder. Let him be fully persuaded in Your calling and favor on his life. Let wisdom and favor be his portion. Open doors and opportunities for him to advance Your kingdom. Bless him and make him a blessing to this generation. Anoint him to do everything You've created him to do. Lord, when You called him, You also downloaded into him everything he needs to succeed. You enabled him to walk in his calling and become the man of God You created him to be.

Let him excel in his work and stand before kings. Lord, establish the works of his hands. Lord, let my husband's labor bring success, joy, prosperity, and fulfillment. Let the hands of the diligent rule in the earth.

Give my husband fresh vision and insight into Your plans for his life. Fill him with the knowledge of Your will in wisdom and spiritual understanding. Let him be a man of righteousness and truth. Give him dreams and visions that will lead him by Your Spirit. Redeem his time and restore the years the locusts have eaten. Give Him vision and a plan

for the future. Give him health and strength to finish the work You've assigned to his hand.

Father, You know what makes him happy and fulfilled. I decree that the blessing of the Lord will make him rich and that all sorrow will be taken away.

Give him the power to get wealth to establish Your covenant in the earth. I decree that his money will not be stolen, wasted, or devoured. Because he is a tither and generous giver, You are opening up the windows of heaven and pouring out blessings to the full that overflow. Make him a blessing to this generation. Unite his heart to fear Your name. Let him walk uprightly before You all the days of his life. In Jesus' name I pray. Amen.

THE DAUGHTERS OF SARAH

…as Sarah obeyed Abraham, calling him lord, whose daughters you are if you do good and are not afraid with any terror.
—1 Peter 3:6

Women with the Sarah anointing are the daughters of Sarah. They have inherited a spiritual legacy of faith passed down from generation to generation. They are daughters of promise, daughters of the blessing God gave to Sarah.

The term *daughters of Sarah* is based on instruction the apostle Peter gave to wives:

> Wives, likewise, be submissive to your own husbands, that even if some do not obey the word, they, without a word, may be won by the conduct of their wives, when they observe your chaste conduct accompanied by fear. Do not let your adornment be merely outward—arranging the hair, wearing gold, or putting on fine apparel—rather let it be the hidden person of the heart, with the incorruptible beauty of a gentle and quiet spirit, which is very precious in the sight of God. For in this manner, in former times, the holy women who trusted in God

also adorned themselves, being submissive to their own husbands, as Sarah obeyed Abraham, calling him lord, whose daughters you are if you do good and are not afraid with any terror.

—1 PETER 3:1–6

The apostle Peter was calling to mind "former times," referring back to a time around four thousand years ago and about two thousand years before he wrote the letter. It is the idea contained in the Book of Jeremiah about restoring the ancient pathways:

Thus says the LORD: "Stand in the ways and see, and ask for the old paths, where the good way is, and walk in it; then you will find rest for your souls."

—JEREMIAH 6:16

When modern-day Sarahs look back to glean the lessons from Sarah's life and faith to apply to their lives today, they are restoring the ancient pathways. God didn't give us Sarah's legacy of faith and the legacy of faith of countless other people just so we can go to heaven someday. He wants us to know the good way to walk, He wants us to follow the right paths, and He wants us to find rest and be at peace.

The daughters of Sarah are being called to restore the ancient paths and to restore faith, the power of femininity, vision, fruitfulness, fearlessness, unity, moral excellence, and all the other aspects of the Sarah anointing. But there is something that often gets in the way: the spirit of Jezebel.

The Spirit of Jezebel

The spirit of Jezebel is the antithesis to the Sarah anointing. We already talked about Jezebel as an example of a helpmeet gone bad, but there is more to Jezebel than that.

Jezebel's name has several different meanings that illustrate the Jezebel spirit's opposition to the Sarah anointing. For example, Jezebel means unchaste,[1] but 1 Peter 3:2 refers to the "chaste conduct" of the daughters of Sarah. Jezebel also means unhusbanded and not honored by cohabitation.[2] This carries the idea of a married woman who is living a separate life from her husband, as though she has a mindset that keeps her separate in her heart. But the daughters of Sarah are women who are helpers, are fruitful, and walk in unity with their husbands.

The ultimate spirit behind the spirit of Jezebel is fear, which is also in opposition to the fearlessness of Sarah's daughters. That fear causes a need to control and have power, but it is rooted in the lack of trust caused by a man in a woman's life who was not willing to cover her, support her, and protect her, whether it was her husband or her father or another man. For Jezebel, it could have been both her father and her husband. Jezebel was a princess, the daughter of Ethbaal, king of the Sidonians. It is quite possible that Jezebel was a political pawn, sold to the highest bidder in a time when alliances between kingdoms were built on intermarriages. Jezebel ended up married to a man who had a temper tantrum because he couldn't buy a vineyard he wanted and surrendered his authority to her without a

second thought. Again, there wouldn't have been a Jezebel if there hadn't been an Ahab.

Jezebel likely felt afraid and rejected by the men who were supposed to lead and protect her. She couldn't trust them, so she needed to control everything herself to make sure she was protected and safe. She wanted the power. She wanted to make the decisions.

In the world we live in today, it is all too common for women to be put in a position where they feel the need to control everything themselves. With the breakdown of the family, countless women have grown up without an Abraham or a son of Abraham to be that man of integrity and strength in their lives whom they can trust and who empowers them to be confident women. Instead, they have been conditioned to try and control everything themselves, to hold tightly to whatever power they can out of fear and lack of trust. It is the spirit of Jezebel.

As a single woman, my soul was being affected by the spirit of Jezebel, but I didn't realize it. Sometimes these spirits are in our bloodline. I come from a strong matriarchal family. The women rule everything. When my mother died, my grandmother, who was fifty-five at the time, suddenly had three little girls to raise. She had made a covenant with my mother to not separate me and my sisters. My grandmother had the control, but her need to control was because of her fear and pain. She ruled us with an iron fist with the idea in mind that even though she would be in her seventies when we were teenagers, we would have the fear of God in us. Because I was the oldest, I grew up with the idea in my

heart that I was going to take care of my sisters. I would get you before you could get me. I would do whatever I could to protect myself. My need to control was rooted in fear, just as it was with my grandmother.

When the Jezebel spirit was first identified to me as a spirit to control, make decisions, and not trust, I didn't want to get rid of it. I felt like it had gotten me to where I was. I didn't have a husband, or anyone for that matter, so I wasn't getting rid of it. Because of my fear, I needed to control everything so I could make sure everything got done.

During a time of deliverance and prayer, when they were casting out devils, someone told me, "Michelle, this stronghold of Jezebel is not going because you're in agreement with it." And I was. It was not until I found out through Scripture about all the harm the spirit of Jezebel causes that I decided to fall out of agreement with it. I spent two days in prayer, asking the Holy Spirit to show me where the Jezebel spirit was operating in my life. I studied the Jezebel spirit and its operations, and I saw myself in it. I discovered that rejection and the fear of rejection were the doorkeepers to Jezebel.

The Word of the Lord is what enabled me to really see what was going on.

> For the word of God is living and powerful, and sharper than any two-edged sword, piercing even to the division of soul and spirit, and of joints and marrow, and is a discerner of the thoughts and intents of the heart.
>
> —Hebrews 4:12

The Word of the Lord is a sword, dividing even soul from spirit. It separated my soul from my spirit, and the Holy Spirit took me through seasons of my life to show me the Jezebel spirit operating in some of what I thought were my most glorious moments. My soul—my mind, will, and emotions—had been in agreement with the spirit, but after the Holy Spirit opened my eyes to its operations, the agreement was a thing of the past.

The Jezebel spirit is fueled by fear, but if you are a daughter of Sarah, you are not going to be controlled by fear. The Word says, "There is no fear in love; but perfect love casts out fear" (1 John 4:18). God is love, and His love can drive out your fear.

You also have to trust God. When you trust God, trust in His provision, and live as if you trust Him, all those issues of fear and control come off in layers. And don't let the big lie that women are second-class citizens in the eyes of God hold you back. Settle that issue with God. You are precious in His sight. You are a Daddy's girl. You are accepted and loved without limitation.

When you are sincere about renewing your mind and wanting to be transformed, God will send you a witness. In my life I found that after I fell out of agreement with the Jezebel spirit, my spiritual mom cast that spirit out, and I started trusting, the Lord sent godly men into my life who wanted to help me in ministry or who opened a door for me without wanting anything in return. I found that I was welcomed as a part of teams, but I didn't have to be like the men. They wanted and valued the fullness of who I was as

a woman. I could feel the femininity of who I was, and they began to validate me as a woman and as a leader by adding me to the team.

Daughter of Sarah, to come into agreement with the Sarah anointing, you have to fall out of agreement with the spirit of Jezebel. Pray and ask the Holy Spirit to show you if the Jezebel spirit is operating in your life. If it is, make the decision to fall out of agreement with it. Let someone pray for you and cast the spirit out. Renew your mind with the Word of God. Then start to trust God.

Restore the Ancient Pathways

Once you get the spirit of Jezebel out of the way, it is time to restore the ancient pathways. It is time to be the woman God designed you to be. It is time to let God redefine you with His Word.

You need to renew your mind with the Word of God. There are all kinds of lies that we believe about ourselves as women. The lies might come from the world, traditions of men, misinterpretations of Scripture, or another source, but they all need to be counteracted with the truth of the Word.

> See, I have this day set you over the nations and over the kingdoms, to root out and to pull down, to destroy and to throw down, to build and to plant.
> —JEREMIAH 1:10

We already talked about the big lie that women are second class, but there are others. Take a fresh look at the Word

of God and allow the Holy Spirit to help you root out, pull down, and destroy all the lies so you can build up the truth in their place.

For example, some women have been taught that they need to submit to all men without question. But 1 Peter 3:1 says, "Wives, likewise, be submissive *to your own husbands*" (emphasis added). And while it is true that we are supposed to submit to the authority God has placed over us, all men are not in authority over us. We need to treat men with honor and respect, but we don't necessarily need to submit to all of them.

First Peter 3:7 gives this instruction to husbands:

> Husbands, likewise, dwell with them with under-
> standing, giving honor to the wife, as to the weaker
> vessel, and as being heirs together of the grace of
> life, that your prayers may not be hindered.

The phrase *weaker vessel* has led to the teaching that women are inferior to men, physically, intellectually, and spiritually. But the Greek word for *vessel* is *skeuos*. It means vessel, equipment, or apparatus. It is referring to the physical body of a woman, not her intellectual or spiritual capacity. A man isn't supposed to honor his wife because she is stupid or inferior. She is physically weaker, and that is not a bad thing. It just means women's bodies are different. It's how women were made.

The same word used for *vessels* in 1 Peter is also used in another verse:

> But we have this treasure in earthen vessels, that the
> excellence of the power may be of God and not of us.
>
> —2 CORINTHIANS 4:7

Both men and women are like vessels made of clay. The Book of Isaiah says, "O LORD, You are our Father; we are the clay, and You our potter; and all we are the work of Your hand" (64:8). God designed each of us, both male and female, exactly the way He wanted to. But as vessels of clay, our bodies can break. We all have physical weakness, men and women alike. But that weakness just serves to show the glory of God at work in us all the more.

Society has tried to turn some of women's God-given characteristics into negative things and make us feel that we need to be more like men. But that is a lie from the enemy. God designed women the way He did on purpose, and the things that make us different are gifts. For example, women tend to be much more sensitive than men. We cry more easily when our feelings get hurt, but that is OK because that is how God made us. And that sensitivity, which society often labels as negative, can be a gift. Because of our sensitive natures, we more easily pick up on how people are feeling, and there can be protection in that. It can also make us more sensitive to the things of the Spirit.

Our passage in 1 Peter also says this:

> Do not let your adornment be merely outward—
> arranging the hair, wearing gold, or putting on fine
> apparel—rather let it be the hidden person of the

> heart, with the incorruptible beauty of a gentle and
> quiet spirit, which is very precious in the sight of God.
>
> —1 PETER 3:3–4

Some women have been taught wrongly about modesty. They think that they need to play down the natural beauty God has given them by not wearing makeup or jewelry, covering their hair, wearing plain clothing, wearing skirts that go to their ankles, and so on. But Peter didn't say, "Do not let your adornment be outward." He said, "Do not let your adornment be *merely* outward." That means it is OK for you to dress in a way that makes you feel comfortable and confident. It is OK to do your makeup and hair in a way that makes you feel beautiful. Do you need to be modest? Absolutely. But you are not responsible for the lust in men's hearts.

The key to modesty is to put on Christ first.

> Put on the Lord Jesus Christ, and make no provision for the flesh, to fulfill its lusts.
>
> —ROMANS 13:14

Adorning yourself is a deliberate action. It's a thoughtful action. It is putting something on. When you put on Christ first, God will guide you about the other things you choose to put on. You can put on some eye shadow, but keep your eyes fixed on Jesus. Use some facial cleanser, but make sure you are being washed in the water of the Word. Try out that new lip color, but make sure you are speaking words of life. Wear your favorite blue dress, but make sure you are clothed

in righteousness. Put on your beautiful earrings, but make sure you are hearing from the Lord.

And remember, while you are indeed beautiful on the outside, you also need to be beautiful on the inside. Your physical beauty may fade as you get older, but your inner beauty never will. Speaking of the *chayil* woman, Solomon wrote:

> Her children rise up and call her blessed; her husband also, and he praises her: "Many daughters have done well, but you excel them all." Charm is deceitful and beauty is passing, but a woman who fears the LORD, she shall be praised.
>
> —PROVERBS 31:28–30

Do Good

In addition to not being afraid, the other key characteristic of the daughters of Sarah is doing good. Women with the Sarah anointing have moral excellence, and the fruit of that moral excellence is good works.

The daughters of Sarah are also women of great faith, and that faith produces good works. In fact, God created you for good works and even prepared those good works just for you ahead of time.

> For we are His workmanship, created in Christ Jesus for good works, which God prepared beforehand that we should walk in them.
>
> —EPHESIANS 2:10

The good works that you do serve as a shining light that brings glory to God.

> Let your light so shine before men, that they may see
> your good works and glorify your Father in heaven.
> —MATTHEW 5:16

Following the ancient paths, knowing which way is the good one, embracing your identity as a woman of God, walking in good works, being beautiful inside and out, and being a woman who is courageous and fearless—these are all characteristics of the daughters of Sarah. They are part of the legacy of faith that has been passed down to you through the generations. You are a holy woman who trusts God, just as the holy women of former times did. You are a daughter of Sarah.

Declarations for the Daughters of Sarah

I am a daughter of Sarah.

I do good.

I am not afraid with any terror.

I will restore the ancient pathways.

I know the good way to walk.

I renounce the spirit of Jezebel. I am not in agreement with that spirit.

God's love is perfect and casts out my fear.

I trust God.

I am accepted and loved without limitation.

I renew my mind with the Word of God.

I root out, pull down, and destroy all the lies of the enemy and build up truth in their place.

I am beautiful inside and out.

I have a gentle and quiet spirit, which is very precious in the sight of God.

I am modest.

I put on Christ first.

I keep my eyes fixed on Jesus.

I am washed in the water of the Word.

I am clothed in righteousness.

I am a woman who fears the Lord.

I am God's workmanship, and I walk in the good works He prepared for me.

NOTES

Introduction

1. Blue Letter Bible, s.v. "*śāray*," accessed November 4, 2021, https://www.blueletterbible.org/lexicon/h8297/kjv/wlc/0-1/.
2. Blue Letter Bible, s.v. "*śārâ*," accessed November 4, 2021, https://www.blueletterbible.org/lexicon/h8283/kjv/wlc/0-1/; Blue Letter Bible, s.v. "*śārâ*," accessed November 4, 2021, https://www.blueletterbible.org/lexicon/h8282/kjv/wlc/0-1/.

Chapter 1

1. Blue Letter Bible, s.v. "*dynamis*," accessed November 4, 2021, https://www.blueletterbible.org/lexicon/g1411/kjv/tr/0-1/.
2. Blue Letter Bible, s.v. "*ḥayil*," accessed November 4, 2021, https://www.blueletterbible.org/lexicon/h2428/kjv/wlc/0-1/.
3. Blue Letter Bible, s.v. "*pistis*," accessed November 4, 2021, https://www.blueletterbible.org/lexicon/g4102/kjv/tr/0-1/.
4. Blue Letter Bible, s.v. "*kakōs*," accessed November 6, 2021, https://www.blueletterbible.org/lexicon/g2560/kjv/tr/0-1/.

5. Blue Letter Bible, s.v. "*yāḏaʿ*," accessed November 18, 2021, https://www.blueletterbible.org/lexicon/h3045/kjv/wlc/0-1/.

Chapter 2

1. Blue Letter Bible, s.v. "*miš'ālâ*," accessed November 6, 2021, https://www.blueletterbible.org/lexicon/h4862/kjv/wlc/0-1/.
2. Blue Letter Bible, s.v. "*katechō*," accessed November 6, 2021, https://www.blueletterbible.org/lexicon/g2722/kjv/tr/0-1/.

Chapter 3

1. *Merriam-Webster*, s.v. "perception," accessed November 9, 2021, https://www.merriam-webster.com/dictionary/perception.
2. *Merriam-Webster*, s.v. "depth perception," accessed November 9, 2021, https://www.merriam-webster.com/dictionary/depth%20perception.
3. Blue Letter Bible, s.v. "*dynatos*," accessed November 9, 2021, https://www.blueletterbible.org/lexicon/g1415/kjv/tr/0-1/.
4. *Merriam-Webster*, s.v. "capacity," accessed November 9, 2021, https://www.merriam-webster.com/dictionary/capacity.
5. Blue Letter Bible, s.v. "*ergon*," accessed November 6, 2021, https://www.blueletterbible.org/lexicon/g2041/kjv/tr/0-1/.

Chapter 4

1. Blue Letter Bible, s.v. "'ēzer," accessed November 4, 2021, https://www.blueletterbible.org/lexicon/h5828/ kjv/wlc/0-1/; Blue Letter Bible, s.v. "'āzar," accessed November 4, 2021, https://www.blueletterbible.org/ lexicon/h5826/kjv/wlc/0-1/.

2. Blue Letter Bible, s.v. "hypotassō," accessed November 6, 2021, https://www.blueletterbible.org/lexicon/ g5293/kjv/tr/0-1/.

Chapter 5

1. Blue Letter Bible, s.v. "kairos," accessed November 11, 2021, https://www.blueletterbible.org/lexicon/g2540/ kjv/tr/0-1/.

2. Blue Letter Bible, s.v. "'ēt," accessed November 11, 2021, https://www.blueletterbible.org/lexicon/h6256/ kjv/wlc/0-1/.

3. Blue Letter Bible, s.v. "mô'ēḏ," accessed November 11, 2021, https://www.blueletterbible.org/lexicon/h4150/ kjv/wlc/0-1/.

4. Blue Letter Bible, s.v. "qāvâ," accessed November 11, 2021, https://www.blueletterbible.org/lexicon/h6960/ kjv/wlc/0-1/.

5. Blue Letter Bible, s.v. "plērōma," accessed November 11, 2021, https://www.blueletterbible.org/lexicon/ g4138/kjv/tr/0-1/.

6. Blue Letter Bible, s.v. *"plēroō,"* accessed November 11, 2021, https://www.blueletterbible.org/lexicon/g4137/kjv/tr/0-1/.

Chapter 6

1. Blue Letter Bible, s.v. *"ṣāḥaq,"* accessed November 11, 2021, https://www.blueletterbible.org/lexicon/h6711/kjv/wlc/0-1/.
2. Blue Letter Bible, s.v. *"diōkō,"* accessed November 11, 2021, https://www.blueletterbible.org/lexicon/g1377/kjv/tr/0-1/.
3. Maya Angelou, "When someone shows you who they are, believe them the first time," Twitter, June 12, 2015, 12:01 p.m., https://twitter.com/drmayaangelou/status/609390085604311040?lang=en.

Chapter 7

1. J. Lee Grady, *Fearless Daughters of the Bible: What You Can Learn From 22 Women Who Challenged Tradition, Fought Injustice and Dared to Lead* (Grand Rapids, MI: Chosen Books, 2012), 31–32.
2. Michelle McClain-Walters, *The Prophetic Advantage* (Lake Mary, FL: Charisma House, 2012), 86–87.
3. Orthodox Wiki, s.v. "repentance," accessed November 29, 2021, http://en.orthodoxwiki.org/Repentance.

Chapter 8

1. Blue Letter Bible, s.v. "'*îzebel*," accessed November 6, 2021, https://www.blueletterbible.org/lexicon/h348/kjv/wlc/0-1/.

2. "Jezebel Meaning," Abarim Publications, updated August 24, 2021, https://www.abarim-publications.com/Meaning/Jezebel.html.

Thank You

FOR READING *THE SARAH ANOINTING.*

I hope you have seen how God is awakening you to bring forth His plans and purposes for the glory of His kingdom here on earth. It is women like *you* that God is calling to bring hope and light to the nations!

AS MY WAY OF SAYING THANK YOU, I AM OFFERING YOU A COUPLE OF GIFTS:

- E-book: *The Deborah Anointing*
- E-book: *The Deborah Anointing Study Guide*

To get these FREE GIFTS, please go to:
www.MichelleMcClainBooks.com/free

Scan here for your FREE gift:

Thanks again, and God bless you,

CHARISMA HOUSE

Made in United States
Orlando, FL
23 January 2023

28976231R00080